CW00547219

Phill Niblock Nothing but working

Mathieu Copeland (ed.)

Verlag der Buchhandlung Walther und Franz König, Köln

Published on the occasion of Phill Niblock's 90th birthday and the tenth anniversary of—
Nothing but working – Phill Niblock, a retrospective
An exhibition by Mathieu Copeland
At Circuit, Contemporary Art Centre and Musée de l'Elysée, Lausanne, Switzerland, 30 January–14 May, 2013

touring as
Phill Niblock: Working For a Title
At Dum Umení, Dum pánu z Kunštátu, Brno, Czech Republic, 25 November 2015–25 January 2016

Editor & Designer: Mathieu Copeland

Copyeditor & Proofreader: Michèle Smith

Color Separation & Printing: Musumeci, S.p.A., Quart (Aosta)

Photographic credits:
All images by Phill Niblock, courtesy the artist
except
David Gagnebin-de Bons—p.34; 68. Exhibition views, Courtesy Circuit
Yannick Luthy—p.54; 88. Exhibition views, Courtesy Musée de l'Elysée
Michaela Dvoráková—p.18; 32; 38; 40; 84; 92. Exhibition views, Courtesy Dum pánu z Kunštátu
Tim Brotherton & Katie Lock—p.56. *Environments* installation at Tate Modern (2017) curated by Andrea Lissoni,
exhibition view with dancer Elisabeth Schilling. Courtesy the artist
JJ Murphy—p.4. Courtesy the artist
Courtesy of Experimental Intermedia—p.16
Monica Evans-Bough—p.21. Courtesy Joan La Barbara Archive
Katherine Liberovskaya—p.23
Back cover—self-portrait in Ghent, Phill Niblock, 2007

Our most sincere gratitude goes to—
Michele Abrigo, Francis Baudevin, Victoria Brooks, Maximus Copeland, Mary Rinebold Copeland, Jozef Cseres,
Ann Danoff, Guy de Bievre, Philippe Decrauzat, Lydia Dorner, Nicolas Eigenheer, Kenneth Goldsmith,
Tom Johnson, François Kohler, Franz König, Joan La Barbara, Anne Lacoste, Katherine Liberovskaya, Alan Licht,
Andrea Lissoni, Olivier Michelon, Raoul Middleman (in memoriam), Meredith Monk, Mgr. Terezie Petišková,
Robert Poss, Dana Reitz, Paul Smith, Susan Stenger, Gerd Stern, Sam Stourdzé, Elaine Summers (in memoriam),
Carly Whitefield, everyone at Circuit, Musée de l'Elysée, and Dum umení.

The exhibition was made possible thanks to Circuit's 2013 annual support—
Ville de Lausanne, Etat de Vaud, Loterie Romande, Fondation Alfred Richterich, Fondation Casino Barrière
Montreux, Banque Cantonale Vaudoise, Pour-cent culturel Migros, Profiducia Conseils SA

Published by Mathieu Copeland Presents and Verlag der Buchhandlung Walther und Franz König, Köln

Distribution:
Buchhandlung Walther König
Ehrenstr. 4, D - 50672 Köln
Tel: +49 (0) 221 / 20 59 6 53
verlag@buchhandlung-walther-koenig.de

ISBN: 978-3-7533-0417-5

Printed in Europe

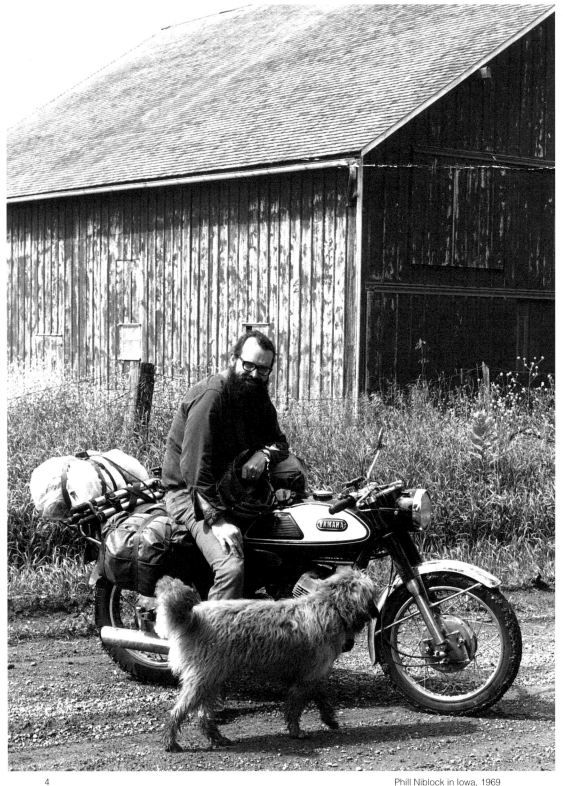

Phill Niblock in Iowa, 1969

The movements of the artist at work
Mathieu Copeland

The celebrated intermedia artist Phill Niblock is always at work. So much so that his first retrospective, the year he turned 80, was titled *Nothing but working* (Contemporary Art Centre Circuit and Musée de l'Elysée, Lausanne, Switzerland, 30 January–14 May, 2013), and his second, two years later, *Working for a title* (Dum Umení, Brno, Czech Republic, 25 November 2015–25 January 2016). For 60 years, Niblock has endeavored to transform our perception and experiences through a synthesis of minimalist music, structural cinema, dance performance, improvised theater, systematic art, and ethnographic photography.

Born under Libra on October 2, 1933, in Anderson, Indiana, Niblock studied economics at the University of Indiana and was inducted into the US Army on graduating in 1956. He was trained in Morse code at Fort Knox and assigned to Fort Rucker, Alabama, serving for exactly two years and one day.[1] Released from the army, Niblock settled in New York City, where he found jobs that "really aren't worth recalling"[2] until his hiring by CUNY in 1971. On June 1,1968, he moved into the loft where he still lives. Located on the third floor of 224 Centre Street in New York, The Loft, aka The Th*eir*d Floor, is the hub of Experimental Intermedia, of which Niblock was a founding artist and member and that he has directed since 1985.

One of the great experimental composers of our time, Phill Niblock began his artistic career as a photographer. A jazz aficionado, between 1960 and 1964 Niblock photographed concerts and recording sessions around New York in his free time, producing profound and invaluable aesthetic studies of legendary musicians at work: including Max Roach, Charles Mingus, Ben Webster, Billy Strayhorn, Paul Gonsalves, Ray Nance, Johnny Hodges, Coleman Hawkins, Roy Eldridge, Mary Lou Williams, Eddie Gomez, Charlie Byrd, and especially the Duke.

During a meeting of the Duke Ellington Jazz Society, Niblock met Jerry Valburn, a recording engineer and archivist, who invited him to a concert on Long Island by Duke Ellington and His Orchestra and to a recording session by the band at Columbia Records. Valburn then introduced him to the jazz critic and biographer Stanley Dance, a close friend of Duke Ellington's. After showing them his photographs, Niblock was invited to many more of Ellington's sessions and began supplying prints for jazz magazines and album covers, including *Great Times!* (1963), the last record to be issued by Riverside Records, which, he later recalled, "was not credited to me (sigh)."[3]

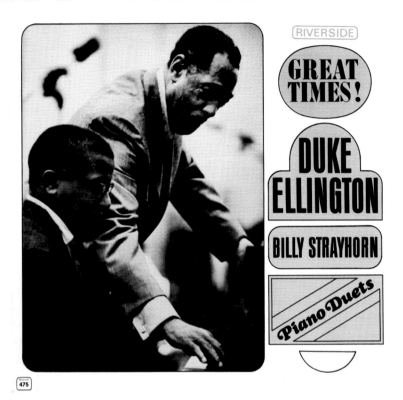

RIVERSIDE

GREAT TIMES!

DUKE ELLINGTON

BILLY STRAYHORN

Piano Duets

475

A gifted amateur, Niblock was deeply invested in the craft and art of photography. He greatly admired the work of Edward Weston and strove for a similar purity in his own photographs, especially in the print quality. At the beginning of the 1960s, he had the good fortune to meet the pioneering photographer and avant-garde filmmaker Ralph Steiner (1889–1986), who lived around the corner from him in Manhattan and whose seminar series on photography he had been following. A decade later, in her who's who of filmmakers, Abigail Nelson records that Steiner had a deep effect on Niblock's handling of images. "From Steiner, Phill learned that the basis of photography is recording the tonalities that are generated by light. One can either record those tonalities that exist or else manipulate them in some way."[4] Steiner remained an important influence for the development of Niblock's art. Not only in terms of Niblock's photography, even though Niblock recalled that Steiner did say early on that he was a lousy photo printer, so he got busy to "prove...", but also in his films. Steiner's *H2O* (1929) study of the patterns of light and shadows on water, or the repetitive visual forms of *Mechanical Principles* (1930) are fundamental features of Niblock's later films. Following a brief visit by Niblock to his home in Vermont in 1975, Steiner wrote a passionate letter full of praise ("I think you have genius – something most valuable to offer to the world") and criticism (Steiner would repeat in the margins of the letter's three pages the same sentence: "anything is permissible if it gives joy – if it opens people to feeling. There are all of those who need opening – not just on Phill Niblock's

Album cover, *Great Times! – Duke Ellington / Billy Strayhorn Piano Duets*, Riverside Records RM 475, 1963, featuring an uncredited photograph by Phill Niblock (see p.30)

level"). The letter concludes with this advice: "So screw your fellow film makers. Screw your fellow music makers. Screw your peer age group. Throw off what was, if you wish, but don't be influenced by anything but what is warm, affirmative, human, loving, contributory, additive, Niblockish, Phillish."[5]

When Niblock emerged as a photographer, the Underground Gallery, at 51 East 10th Street, was one of the few New York galleries devoted to photography. An avid gallery and museum goer, he often attended the gallery's exhibitions. He got to know the owner, Norbert Kleber (a Swiss who worked for Paillard, maker of Bolex film cameras), well enough to propose a show of his work at the gallery. Simply titled *Phill Niblock*, this first exhibition of his photographs took place in February 1966. Niblock decided against showing his prints of jazz musicians, as they were more about the subjects than the aesthetics of his photographs. Instead, he selected photographs from his journeys around New York City and the eastern US, especially those taken inside the abandoned hospital on Welfare Island (now Roosevelt Island), located in the middle of the East River. Niblock found the patina of dust hard to resist.

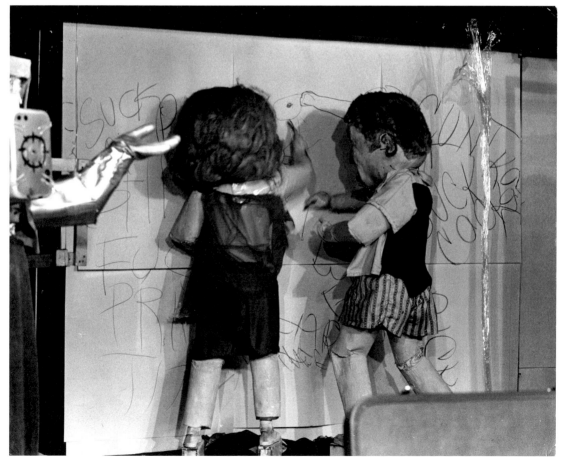

Members of The Open Theater destroy a commercial love-nest in Jean-Claude van Itallie's *America Hurrah*, 1966, directed by Michael Kahn.

Expanding his practice, Niblock ventured next into theater photography, forming a close connection with actors from Joseph Chaikin's Open Theater in New York and with Belgian-born American playwright and performer Jean-Claude van Itallie. Niblock documented Itallie's trilogy of one-act, anti-Vietnam War plays, *America Hurrah* (1966), as well as the full-length drama *The Serpent* (1968), a play developed during workshops and improvisations at The Open Theater. On the strength of Niblock's work, Itallie went on to write a series of unrealized pieces with Niblock in mind.[6]

In 1965, encouraged by Elaine Summers, Niblock began making films for the dancers and choreographers who gathered at Judson Memorial Church in Greenwich Village. Niblock was cameraman on Yvonne Rainer's *Trio Film* (1968) and *Line* (1969), Meredith Monk's *Children* (1967) and *Ball Bearing* (1968), and Tina Croll's *Fields* (1969). He also made a never-released film of Lucinda Childs performing her latest dance choreography. In 1967, Niblock created a film, with a soundtrack by Daniel Zellman, for the prelude and the postlude of *An Evening of Dance Theater by Meredith Monk* at The Village Theatre. Tellingly, the program notes announce that the film was to "run for ten minutes following the concert. The audience is invited to move around, converse, etc."[7] Another striking film from this period is the eponymous three-minute short he made in March 1966 at the Judson Gallery inside Anthony Cox and Yoko Ono's collaborative environment, *The Stone*.

Working with Summers taught Niblock a great deal about movement. "It may seem a contradiction," writes Nelson in her profile, "that even though his camera is often stationary, his films are full of rhythms, pulsations and shifts of light that flood the screen with movement." Niblock worked extensively with Summers, documenting *Signs* (1965) on 8mm, and collaborating on films for *Walking Dance For Any Number* (Parsons' Kaplan Hall Auditorium, 9 December 1965) and for *Walking Dance*, *Film Landscape*, and *Film All Around the Hall*, at Summers' Intermedia Concert (Judson Memorial Church, 10–11 October 1967).

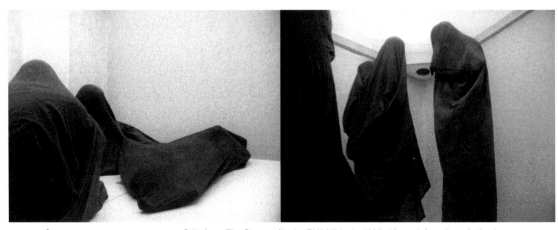

Stills from *The Stone*, a film by Phill Niblock, 1966, 16mm, b&w, silent, 3:10 min

His work with musicians, actors, and dancers led to a series of 16mm sound films made in quick succession between 1966 and 1969, later collected as *Six Films*. The first, *Morning* (1966-69, b&w, 17 min), stemmed from his relationship with the Open Theater, based on an idea conceived with Itallie. This multilayered film is the most narrative of Niblock's works. Internal monologues, scripted by Lee Worley and Michael Corner and voiced by Worley, James Barbosa, Barbara Porte, and Dorothy Lyman, capture the thoughts and anxieties of the characters, who are acted by Cynthia Harris, Sharon Gans, and Joseph Chaikin, as they go through their morning rituals: from waking up and getting ready to preparing a meal for the day.

Of his next production, *The Magic Sun* (1966-68, b&w, 17 min), a film about the Afrofuturist composer Sun Ra and his Arkestra, Nelson writes that it shows:

> Phill's interest in light and movement. Although it seems to be the recording of a concert, it was shot mainly in apartments, with each musician in turn sitting in the same chair in front of one bright light. The exception is the very beginning of the film which was shot outdoors and then reversed so that it is negative. The effect of the rest of the film seems like a negative because high contrast black and white stock was used. The play of black and white shapes is orchestrated to a totally separate soundtrack. The images become more and more abstract, until huge blotches of black struggle to blot out that one intense light as the music reaches a frenzied pitch. It is a film of extraordinary drama and technical virtuosity.[8]

The Magic Sun was screened at Carnegie Hall on 12–13 April 1968 as part of the intermedia performance *The Space Music of Sun Ra*, advertised as "a freeform excursion into the far reaches of sound and sight," and at the Corcoran Gallery of Art in Washington, DC, in August the same year.

His next film, *Dog Track* (1969, color, 8 min), featured a found text read by Barbara Porte, which he considered an "interesting failure." According to Abigail Nelson:

> *Dog Track* was an experiment in the use of non-related sound and image. As we see bland images, bucolic and urban, a narrator describes in flat, matter-of-fact tones her childhood on an Indiana farm. It is, in fact, a Kinsey-like report on bestiality. Funny and bizarre, her "romance" with her dog, Romeo, is told in graphic detail. What Phill wanted was a soundtrack so visually descriptive that people remember having seen a film they have converted into images from the sound track.[9]

The last three films in the series are portraits, each one expanding Niblock's practice in a different way. *Annie* (1968, color, 8 min), about the dancer Ann Danoff, with its collaged soundtrack, is an early sound piece by Niblock. *Max* (1966-68, 7 min) about composer Max Neuhaus, brings together collaged footage, shot by Niblock and edited by David Gearey, with a collaged soundtrack by Neuhaus himself. Lastly, *Raoul* (1968-69, color, 20 min), about the painter Raoul Middleman, makes extensive use of

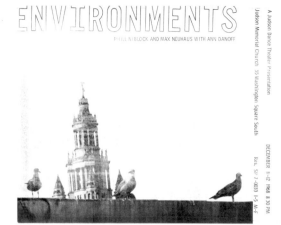

ENVIRONMENTS

PHILL NIBLOCK AND MAX NEUHAUS WITH ANN DANOFF

A Judson Dance Theater Presentation
Judson Memorial Church, 55 Washington Square South

DECEMBER 11–12 1968 8:30 PM
Res. SP 7-0033 1–5 M–F

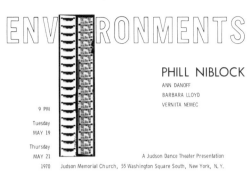

ENVIRONMENTS

PHILL NIBLOCK

ANN DANOFF
BARBARA LLOYD
VERNITA NEMEC

9 PM

Tuesday
MAY 19

Thursday
MAY 21

1970

A Judson Dance Theater Presentation

Judson Memorial Church, 55 Washington Square South, New York, N.Y.

For reservations call SP 7-0033, 1–5 pm, Monday through Friday

time-lapse cinematography, accompanied by an improvised soundtrack by Middleman and Niblock.

Starting in 1968, Niblock began experimenting with combining visual productions and musical scores to create architectural and environmental compositions, which he called *Environments*. The first of the *Environments* was presented at Judson Church on 11–12 December 1968. The film component was projected onto a purpose-built, 12 x 3 meter screen, which allowed for three 16mm images to be shown simultaneously side by side. The poster announced Phill Niblock and Max Neuhaus, with Ann Danoff, a split event. Nelson recalled:

> Phill had two films: one of a dancer, Ann Danoff, and the other of composer-performer, Max Neuhaus, and he decided to show them along with a live performance by each person. It was a learning experience, for he learned what not to do. Using a dancer and a film simultaneously in a live concert piece seemed to muddle the action and disperse the energy. At one point, the split screens were six in number; there were too many images. Three screens are just enough, he feels, while two is a static number. Any more than three spells confusion.[10]

The musical component was written by Niblock for the church organ at Judson. In a 2019 *Artforum* interview, he describes how "the concert actually began with Meredith Monk playing the organ as the audience arrived. At some point, she gets up, walks down and sits in the audience but the organ continues. So I made a recording and I played the recording and faded it in; Monk stopped playing, but the recording was still going."[11]

Between 1969 and 1972, Niblock created three more *Environments*, conceived as a series of "non-verbal theater" events with dance, music and films. For these, Niblock established The Environments Company, a collective of artists that included Barbara Lloyd, Ann Danoff, David Geary, Ivan Taub and Niblock himself. Each of the

Poster designed by Phill Niblock for *Environments* (left) and *Environments II* (right), presented at the Judson Memorial Church, 1968 and 1970 respectively

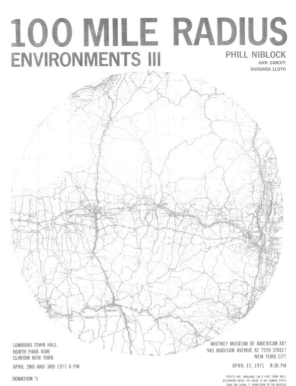

100 MILE RADIUS

ENVIRONMENTS III

PHILL NIBLOCK
ANN DANOFF
BARBARA LLOYD

LUMBARD TOWN HALL
NORTH PARK ROW
CLINTON NEW YORK
APRIL 2ND AND 3RD 1971 8 PM

DONATION $1

WHITNEY MUSEUM OF AMERICAN ART
945 MADISON AVENUE AT 75TH STREET
NEW YORK CITY
APRIL 15, 1971 8:30 PM

TICKETS ARE AVAILABLE ON A FIRST COME BASIS
BEGINNING APRIL 7TH THERE IS NO CHARGE OTHER
THAN THE USUAL $1 ADMISSION TO THE MUSEUM

A DANCE MUSIC FILM EVENT PRODUCED BY THE KIRKLAND ART CENTER
WITH THE SUPPORT OF THE NEW YORK STATE COUNCIL ON THE ARTS

Environments consisted of a choreography of projected movies and slides, interspersed by dancers performing simple movements that merged perfectly with the serenity of the images. Describing the event for readers of the *Village Voice*, Jonas Mekas wrote that *Environments II* "presented movements and images which contained life energy with a minimum of corruption."[12] For fellow composer Gordon Mumma, the *Environments* series produced "massive sound without a hint of musical gesture. The lyrical cinema of Phill Niblock."[13] The music that originally accompanied these performances could, in retrospect, be heard as early experiments in what would soon become Niblock's quintessential minimalist music.

For each event, Niblock extracted the reality of a given territory and, with his collaborators, would generate a dense temporary environment of projected images, music and movement inside a performance or museum space. Nelson summarized their development:

> For *Cross-Country/Environments II*, Phill gathered materials specifically for the event, during a cross-country motorcycle tour in 1969 and down the east coast to Florida in the winter of that year. The event began with slides. Nature materials were now the subject matter of the film section. Live dance was a separate section too.

Poster for *100 Mile Radius/Environments III*, presented at the Kirkland Art Centre in
Clinton, NY, and performed at the Whitney Museum of American Art, 1971

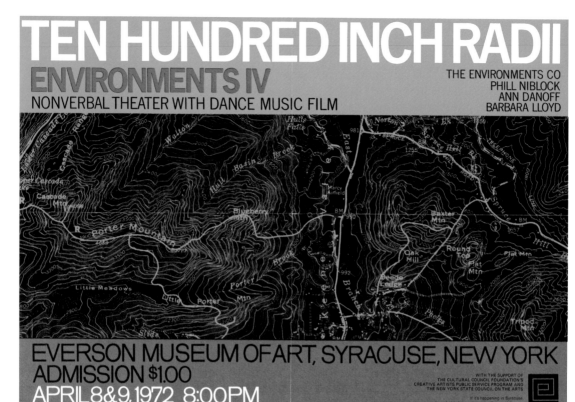

TEN HUNDRED INCH RADII

ENVIRONMENTS IV

NONVERBAL THEATER WITH DANCE MUSIC FILM

THE ENVIRONMENTS CO
PHILL NIBLOCK
ANN DANOFF
BARBARA LLOYD

EVERSON MUSEUM OF ART, SYRACUSE, NEW YORK
ADMISSION $1.00
APRIL 8 & 9, 1972 8:00PM

WITH THE SUPPORT OF
THE CULTURAL COUNCIL FOUNDATION'S
CREATIVE ARTISTS PUBLIC SERVICE PROGRAM AND
THE NEW YORK STATE COUNCIL ON THE ARTS

If it's happening in Syracuse,
its probably happening at the Everson Museum.

Museum performance was a new direction for *100 Mile Radius/Environments III.*
[...] The material was gathered by Phill again on motorcycle, filming in a hundred-
mile radius of Clinton.

By *Ten Hundred Inch Radii/Environments IV*, the format had been finalized. The
essential change was in the film material, with each image lasting much longer.
Phill has tried to make nature simpler, more abstract in the way he looked at it. He
does it "by the closeness of the image, by the exclusion of the background, and
especially by the way I use light." *Ten Hundred Inch Radii* was shot using direct
sunlight only. It becomes for him as much the subject matter of the film as the
flowers and insects, the mountains and streams."[14]

Returning to the origins of the series, it is striking to realize the fluidity in his practice,
from photography to film to music. Niblock gives the following "examples of the
evolution of some material":

[T]he film *Max* became a section of the concert *Environments*; *Annie* was a
section of that concert and became a film. An organ prelude I composed for
Environments was used in the body of the concert *Cross-Country, Environments II,*
and became the soundtrack of the film *Animals*, which was a film section of *Cross-
Country*. From material for the concert, *100 Mile Radius/Environments III*, I cut

Poster for *Ten Hundred Inch Radii/Environments IV*, presented at Everson Museum of Art,
Syracuse, NY, 1972

seven short films – with music composed for *Cross-Country* and *100 Mile Radius* –
for *Free Time*, a program on WNET, Channel 13."[15]
One thing leading to the next, blending almost into one, but announcing radical schisms
and revolutionary works. The next major shift to come was *The Movement of People
Working*.

In late 1972, Niblock embarked on another journey conceived initially as
Environments V, a museum exhibition combining films, slides, environmental sound
and music, but, significantly, no live dancers. A second proposal description for the
same project deletes all references to the *Environments* series, announcing instead the
project and philosophy that would guide him over the next two decades:

> The Project: To look at (by means of film): 1) the relationship to their physical and
> cultural environment of a people whose culture differs from the urban culture
> prevalent in the communities of the United States. 2) the people's performance of
> everyday tasks, e.g. working with tools, cooking, crafts, play. To do this in a way
> which will not restructure the activities. I will not attempt to document the totality
> of a performance sequence, but to extract elements and to make an abstraction
> of form and movement. This base material will be combined into a mosaic
> juxtaposing different kinds of activities, differing age groups, possibly people from
> different areas or tribes.
>
> The Philosophy: To make nonverbal theater which will convey a sense of a
> culture, rather than a literal or literary exposition of a whole culture's activities. To
> affect the senses of the audience with the physical activities of the people, the
> everyday choreography, designed for the needs of living, adapted to the physical
> environment; rather than the verbal communication of the community, either
> conversation among the members, or the literature.[16]

Niblock later admitted that this change of direction "came out of necessity because
I was doing music performances with live dancers, and it was too cumbersome and
expensive to tour with so many people. So I started doing those films that I could
project when performing."[17]

The project portrays human labor in its most elementary form, a choreography of
movements and gestures that dignifies the repetitive mechanical yet natural actions
of workers using non- or semi-industrialized labor methods. The twenty-year series
begins with *Trabajando: People Working the Land* and *Sur: People Working with their
Hands*, both divided in two parts and shot in Mexico and Peru on 16mm Kodachrome
stock between 1973 and 1974. In a succession of tightly framed close-ups and long
shots, *Trabajando Dos* (Mexico, 1974) captures the physical labor of Mexican peasants
in their rural surroundings. Reviewing the film in *ART + CINEMA*, Daryl Chin and Larry

Qualls write, "Though the movement within the frames is almost as still as the camera setups, there is an immediacy and propulsion within each shot and throughout the film." By contrast, *Sur Dos* focuses in on the "work-worn hands and darting fingers" of peasants and craftspeople "as they manipulate the tools of their trade." Chin and Qualls note the influence of his time spent studying Kinetic Awareness with Elaine Summers: "in particular the varying degree of tension and flow which different labors require." "The film's musical and visual sense," they conclude, "is an intense articulation of the waves pulse and pattern in the everyday work of hands."[18] By the time of his exhibition *SUR: the movement of people working* at Wadsworth Atheneum in 1975, Niblock had settled on a title for the entire series to come: *The Movement of People Working*.

Every year from 1973 to 1991, Niblock added a new piece to his mosaic of human labor. The next films in the series, *Tres Familias* (summer 1975) and *Four Libras* (summer 1976) were the last to have autonomous titles. Successive films were simply indexed by place, season and year:

James Bay (summer 1977)
The Arctic (summer 1978)
Lesotho and South Africa (January 1979)
Hong Kong (summer 1979 and 1981)
Portugal (January 1980)
Puerto Rico (January 1982) and Norway (summer 1982)
Brazil (summer 1983 and 1984)
Hungary (summer 1985)
China (summer 1986, 1987 and 1988)
Japan (summer 1989)
Sumatra (summer 1990) and Romania (summer 1991)

Niblock brought the series to a halt in 1991 after shooting his last two films on video[19]. The switch from 16mm to video radically changed the nature of the endeavor. Without the constraints imposed by film, he was left with a daunting load of material to edit. 2005 and 2009 saw a brief reprise of the project when Niblock went to Osaka to capture factory and market workers on video.

Although made while traveling, these films are not travel logs. If anything, *The Movement of People Working* (hereafter, *TMOPW*) is a log of human labor, an accumulation of more than thirty hours of edited footage of people around the world on a shared journey. The films are accompanied by the whole corpus of Niblock's slowly evolving, harmonically minimalist music. Even though not written to accompany the films, Niblock's "music works so perfectly with the films because all the rhythms of life captured and implied visually are present aurally in his music," as Arthur Stidfole notes.[20] The layering of tones echoes the repetitions of the workers' actions. Inherited from previous setups devised for the *Environments* and his experiments projecting

films to music, the ideal presentation of *TMOPW* consists of three films projected side by side, each 4 x 3 meters in size, with sound played from four speakers placed in the corners of the space together with a subwoofer. The films are continuously projected onto each screen and change following an established playlist so that no one film is seen twice simultaneously. Combined with a program that plays back all the music pieces in succession, this arrangement results in a constant renewal of forms, as it continuously offers an exhibition of new juxtapositions of sound and image.

Niblock's composition process was established in 1968 and remains the same to this day, summarized with great efficiency by Tom Johnson as: "no harmony, no melody, no rhythm, no bullshit," later adding, "just sound, vibration, beating…"[21] Niblock explained that his music is "produced by combining a number of tones close together in pitch and of long duration, sounded simultaneously, using traditional instruments. These tones create beats and sum and difference tones, which contribute rhythms and changed timbral characteristics."[22]

The music is recorded and assembled on multitrack tapes, a "meticulous process" that Johnson attributed to Niblock's decade-long experience working with film. In his program notes for *Niblock for Celli/ Celli Plays Niblock*, Niblock writes, "The pieces are made in stages. First, the tones are selected. The musician is tuned during the

my favorite
brown ink

**Nothin
to
advertise**

Phill Niblock

my favorite
typeface

**just
a
poster**

Promotional poster based on Phill Niblock's first LP cover, *nothin to look at, just a record*,
India Navigation, 1982. It was folded, with reviews and program notes tucked inside.

recording session by calibrated sine waves and oscilloscope patterns. Numerous examples of each tone are recorded. These tapes are edited (breathing spaces removed) into blocks of repetitions of each tone and then timed. The timed blocks are assigned to tracks and time slots of the eight or four tracks."[23] In addition to Joseph Celli, the list of musicians that Niblock has composed *for* (the mastery of the musician's instrument is essential for the piece) and composed *with* (a great connivance is established with the player to achieve a precise technical recording) is in itself an impressive international nexus that includes, among many others, David Gibson, Petr Kotik, David Watson, Susan Stenger, Robert Poss, Ulrich Krieger, Jim O'Rourke, Stephen O'Malley. In 1982, a series of his scores were displayed as enlarged photostats for a solo exhibition at London's ICA.

In 1974, John Cage remarked that there "is endless work to be done in the field of electronic music. And many people at work: David Behrman, Gordon Mumma, Robert Ashley, Alvin Lucier, Phill Niblock, to name five."[24] Niblock's instrumental works were produced on tape and performed either as tape or as tape accompanied by live musicians. When performing, the musicians moved around the space playing matching or adjacent tones to those on tape, thus creating shifting pools of beats and changed harmonics. "The musician," the composer explained, "is not a soloist with tape background, but another source of tones within the audience and the space."[25] In placing the loudspeakers in the four corners of the space, Niblock engages with the particular architecture of the space where the music is played, knowing that "each performance space and set of sound reproduction equipment changes the music."[26] On the liner notes of Niblock's debut album *nothin to look at, just a record* (1982), the composer asks listeners to "Please play this record loud." The sound level of his compositions offers a visceral experience of the long drones as we inhabit the ringing, beating overtones. At first, Niblock objected to releasing a record of his music because he was "reluctant to relinquish control of the performance of the music." He realized, however, that "the performance is the playing of the recording under careful circumstances. […] The music changes according to the loudness of playback.

Experimental Intermedia, the loft on the th*ei*rd floor of 224 Centre Street, New York City

This was one of those weeks when so much happened that I wish I could turn in five or six articles instead of one. One of those articles would be devoted to Phill Niblock, a New York filmmaker-composer, whose music has dealt exclusively with tone clusters ever since I became familiar with his work about four years ago. I'd explain how he works with quarter tones and eighth tones, and in fact, likes to cram as many pitches as close together as he can. I'd trace his early experiments, in which he recorded instrumental tones, clipped off all the attacks, and constructed massive textures of sustained clusters on eight- and 16-track tapes, and I'd try to explain how rhythmically active these sustained pieces are, due to the many beats or pulsations which come about as the "out-of-tune" notes jar against one another. I'd have to note that Niblock's many experiments in this direction have been kind of hit-and-miss as far as the resulting musical sensitivity is concerned. But then I'd go on to praise his persistence, and give him a lot of credit for his most recent music. I'd describe the piece for five cellos and tape, and the one for solo English horn and tape, which were presented at the Composers' Forum last Thursday, and try to show how effectively their rich dense sounds filled the space at WBAI's Studio C. Niblock doesn't clip off the attacks any more, he has better control of the exact intonation, he works at more moderate volumes, and the beat rhythms are easier to hear than ever. But the main point would be that his music now blends live instrumental sounds particularly well, thus offering a unique resolution to the **man**-machine conflict.

March 1976

The Niblock String Quartet, which I heard at WBAI's Free Music Store on April 13, was performed by cellist David Gibson who had overdubbed all four parts on a recording and performed an extra part live against the tape. Like most of Niblock's music, each part is a continuous melody of very long tones. The lines move against each other in unpredictable patterns, and the resulting harmonies provide the chief interest. I had a chance to look at the score and found that the 24-minute piece has a clear logic, at least on paper, progressing from a simple tonal sound to a dissonant sound, to a cluster.

April 1974

The music (T H I R) was sustained sounds, hovering around an out-of-tune cluster for a long time. Gradually it seems to become denser, and expands to the upper register -- the piece builds up in a dramatic way. Voice Four -- the sounds are voices, and they are beautifully blended to create an expanse of low-pitched vocal sound. His music has an undefined drifting quality much of the time, which leaves it vague and open to interpretation.

June 1972

Niblock begins by recording sustained tones, sung by voices or played on traditional instruments. Then he clips off all the attacks, giving the sounds a strange dehumanized effect. Later, he splices all these tones together and mixes them, using as many as 16 tracks, and plays the mixture in loud stereo. The recorded quality of his tapes is impeccable, and the sound is extremely rich. The music is quite dissonant, but since it always remains on one dynamic level and avoids any kind of rhythmic gestures, it never seems aggressive or expressionistic. The contrasts are quite sharp between the cold machine-like music, the attractive nature photography, and the silent dancing. In terms of theme or message, they don't belong together at all. But in structural terms these blatantly contrasting elements offset each other quite effectively. End structure is really what it is all about. Despite my groping for descriptive images, Niblock's version of multimedia, like his music, is basically an abstract art.

March 1973

TOM JOHNSON, Village Voice
(Four different reviews)

Excerpts from reviews and articles, double-sided handout edited by Phill Niblock, including
a page featuring four extracts and a drawing by Tom Johnson for the *Village Voice*, 1976

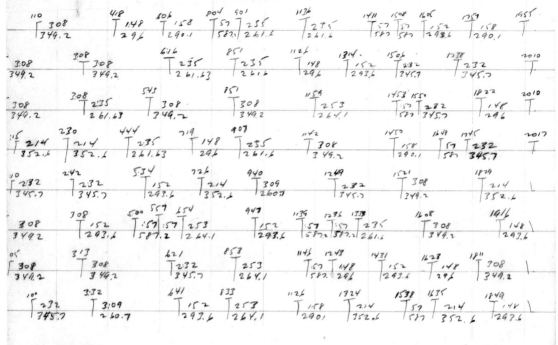

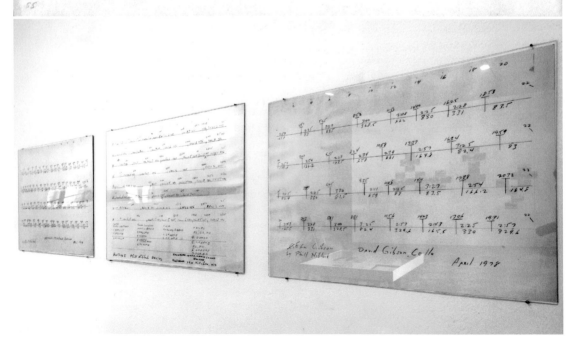

Music Scores Photostats, 1982

The interaction of the upper harmonics changes especially, with much richer overtone patterns being produced at louder levels."[27] As the album title tells us, there is plenty to listen to but nothing to look at on this record – because the films are missing.

1973, the year the artist began *TMOPW*, coincides with Niblock opening his loft as a performance space for the Experimental Intermedia Foundation. EIF (later EI) was founded by Elaine Summers in 1968, four years after she formed The Elaine Summers Dance and Film Co. Niblock was an original member together with Trisha Brown, Philip Corner and Carman Moore. As early as 1972, Niblock hosted concerts of his own compositions in his loft; by mid 1973 he "had sufficiently experimented with the loft as both a private salon and a public performance space to establish it as a venue for the performance and promotion of experimental music and for a dual career for himself as a composer and a curator."[28] Niblock has since produced over a thousand music and intermedia events at EI, including his annual Winter Solstice concerts when, on the longest night of the year, he would play up to eight hours of his own music to screenings of *TMOPW*. The constellation of artists brought in by Niblock over the years is a who's who of historical experimental music and art that includes, to mention just a few, Rhys Chatham, Charlemagne Palestine, Eliane Radigue, Tom Johnson, Joan La Barbara, Jackson MacLow, Yoshi Wada, Peter Zummo, Julius Eastman, Ned Sublette, Christer Hennix, Alvin Lucier, Henry Flynt, Simone Forti, Pauline Oliveros, Ellen Fullman, Tony Conrad, Alison Knowles, Shelley Hirsch, Nicolas Collins, Alan Licht, Katherine Liberovskaya…

In the late 1970s, Niblock resumed working with still photography. The series *Streetcorners in the South Bronx* (1979) was photographed when the area was at its most derelict and deserted, with very few buildings left standing, as though it had been bombed. The photographs were taken from the middle of several intersections, looking down each street, in all four directions, with a street sign in every one. The prints are mounted in a grid, with North at the top. This study of New York is echoed by another geographical portrait, *Buildings along SoHo Broadway* (1988), covering a few blocks of Broadway's "cast iron" district, from Howard Street to Prince Street, in Manhattan. Near to where the artist lives, on a route he often walked, the photographs were taken at the same time of day, avoiding direct sunlight, standing close to the buildings and looking steeply upward, using a Nikon camera loaded with Kodak Tech Pan, a very high resolution, fine grain 35mm film stock. Mounted in a line, the photographs in the series depict and recreate a black-and-white urban landscape. In 1984, while traveling along the north coast from Bahia to Natal for the Brazil installment of *TMOPW*, Niblock carried with him not only his Bolex but his Nikon. In Bahia, he came across a traditional boatyard with handcrafted boats. He photographed the scene intensively and had the film developed through a process that rendered the midtones open. The use of a tripod and long exposure times had blurred the people in the frame, creating a powerful

contrast between their motions and the stillness of the abstract boat forms. In this way, the series of 45 photographs in *Brazil Boatyard* offers yet another social commentary on traditional work and human labor.

While pursuing his work as a composer and curator and adding to his grand oeuvre, *TMOPW*, Niblock embarked on numerous other artistic journeys. He made slide-show pieces best described by the title of one of the last in the series, *Visual Verbal* (ca. 1988). From the "non-verbal" theater of the late 1960s to these "visual verbal" slides of the 1970s and '80s, Niblock's art develops an increasing vocabulary of intangible projected pictures. The slide shows present a choreography of images in time and multiple environments on screen. One series of dissolving slide pieces uses photographs made on his travels in China (1986, 1987 and 1988) and Japan (1989) while filming new installments of *TMOPW*. A distant echo of the films, the still images show us the counterpoint of work as movement: work on pause. Unlike the films, the choreography is not in the repetition of gestures but in the merging of one image into the next.

Throughout his career, Phill Niblock kept returning to film-portraiture. Following the film-portraits of Ann Danoff, Max Neuhaus and Raoul Middleman, Niblock made *3 locations* (1973, 16mm, 6:41 min), a portrait of choreographer and dancer Dana Reitz filmed in three locations contiguous with Staten Island Community College (CUNY), where Niblock taught film, video, and photography from 1971 to 1998. The series of films compiled as *Poets and Talkers* (1975–88, 16mm & video, sound, 131 min) with Armand Schwerner (1975, 11:37 min), Hannah Weiner (1976-77, 10:27 min), Erica Hunt (1981, 18:02 min), Dagmar Apel (1986-87, 34:48 min), and Charlie Morrow (1986-87, 27:35 min). The first two of the series were filmed on color 16mm film stock on location while the others were captured on video in the loft. These are portraits of people working, that is, poets doing poetry. Schwerner, a fellow faculty member, interprets his epic poem *The Tablets* while pacing back and forth on a bluff overlooking the Verrazano-Narrows Bridge. Weiner reads from her book *The Clairvoyant Journal*, first synced to a tight close-up of her head in profile, then unsynced over shots of her typing, then synced again in a medium shot sitting in an armchair with her cat. The three portraits done in Niblock's loft are tightly framed close-ups of the subject's head in profile, filmed with different lighting setups. Shot on VHS-C, a small 20-minute cartridge which determined the length at that time, Hunt's reading starts in complete darkness, her profile is silhouetted against a background that moves through various shades of gray to pure white. Apel improvises a monologue (a form prescribed by Niblock) in German and English, her profile backlit with a key light; Morrow talks in tongues and plays a *scacciapensieri* (jew's-harp), his profile frontlit.

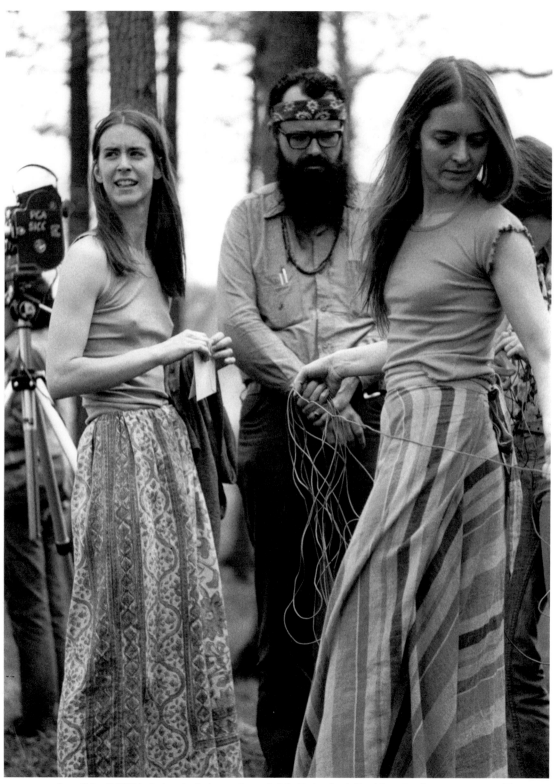

Dana Reitz, Phill Niblock, Joan La Barbara, rehearsal of *An Exploration in Vocal Sound and Movement*, Staten Island, 1975

As a counterpoint to the anonymity of the people working, Phill Niblock celebrates the individual in a series of videos entitled *Anecdotes from Childhood*. This series explores the notion of memory and the expression of personal history through intimate portraits. Between 1985 and 1992, Niblock asked eleven relatives, friends, and accidental acquaintances who grew up in different places – Chang Hsien-Chen (Taiwan), Franck Owen (New York State), Clarence Barlow (India and Cologne), Rina Sherman (South Africa), Veronica "Sweetie" Campbell (Jamaica), Xiu Shaodong (Chengdu, Sichuan), Paul Panhuysen (Netherlands), Hu Hohn (Boston), Xu Xiao Xiang (Chengdu, Sichuan), Yvonne Grant (Jamaica), and his father Earl Niblock (Indiana) – to spontaneously relate some of their childhood memories in front of a video camera. The composition remained the same in each portrait, a continuous shot without edits (bar two exceptions) with the head slightly off-center. Each piece is a monologue, not an interview, and all the participants were told to expect to fill twenty minutes of tape. The duration put them under pressure to remember details and construct a story. Projected alongside the portraits is a slide-show piece called *Light Patterns* (1985-1992), a sequence of high-contrast black-and-white transparencies from Niblock's numerous travels, with each image dissolving into the next. "The dissolving," Guy De Bièvre observed, "unintentionally seems to be mimicking the way the memories fade into one another, the way they interrelate, the way the various time layers are being superimposed."[29] A further confusion is created by the film-portraits playing in pairs, their voice tracks layered over one another: two voices talking at once about early life incidents in a white noise of self-cancelation.

Other portraits include *Terrace of Unintelligibility* and *Some Imaginary Far Away Type Things A.K.A. Lost In The Meshes* (1988, 3/4-inch U-matic video, color, sound, 20:17 min and 33 min respectively), an intimate portrait of Arthur Russell singing and playing the cello, filmed at the loft in 1985; and *Muna Torso* (1992, video, color, silent, 21 min), featuring choreographer Muna Tseng performing for Niblock's camera, in remarkable, tightly framed, silhouetted compositions of her torso and limbs. *Muna Torso* was originally realized as a collaboration between Niblock and Tseng for a full-evening of dance, music and video that included Tseng's anecdote from her childhood in Hong Kong (St Mark's Church, NYC, March 1992 and later at Mousonturm, Frankfurt am Main, Germany).

In 2011, Niblock collaborated with two musicians on separate pieces, *N+M* (the initials of Phill Niblock and Magda Mayas, who plays the piano) and *Nomis* (with Tony Buck on percussion). In them, video cameras were attached to both hands of the performers and the left- and right-hand images they recorded were subsequently superimposed. In *N+M*, six video images are simultaneously displayed on monitors in the space. In *Nomis*, three superimposed images and one image of the whole setup are shown. The sound recordings are played back as a mix of six (*N+M*) or three (*Nomis*) stereo tracks. Similarly, in *HookerNiblock* (2019, HD video, color, 17:49 min), drummer William Hooker

is portrayed through the movement of the cymbals on his drum kit. All these works take us within the instrument to create a portrait of music being played.

Sensitive to the dialogue between himself and his subjects, the choice to work with a musician is essential and eminently personal to the way Niblock composes. The musical compositions reveal a similar level of trust and respect as those on film. Musicians are invited to compose a piece suited to their artistry and talent for playing a given instrument. The relationship is egalitarian. They bring their musicianship and he brings his audio-visual virtuosity to the project. The precise compositional and performative construct of these pieces is encapsulated in the title of his second album: Phill Niblock *for* a musician. The musician *plays* Niblock.

Since 2001, Niblock has maintained a creative partnership with the Canadian intermedia artist Katherine Liberovskaya. Their collaboration has produced numerous video installations, such as *Babel-On* (2003), an audio-video exploration of the melodic and rhythmic dimensions of spoken languages, an experiential piece that evokes the non-verbal possibilities of vocal communication, and the trilogy *Threshold of Predictability* (2014–17), a series of contemplative videos, each one slowly unfolding a single predictable event for the duration of a long drone composition by Niblock. In 2006, they started live mixing Liberovskaya's extensive video database and Niblock's archive of pre-recorded sounds. Their joint performances include *Reconstructed Landscapes*, an ongoing series that uses all sorts of minute visual and sonic details, captured by Liberovskaya and recorded by Niblock respectively, as source material for live events that remix them into landscapes shaped by the artists' personal sensibilities. Their responsiveness to environments and materials is the root of a shared obsession with the immediate reality of any given place and time. This concern is evident in Niblock's first exhibition at the Underground Gallery, in the *Environments*, right up to recent works such as his beautiful video piece *Meudrone* (2014, HD video, color, 47:45 min), an intimate study of the flora in the garden of André Bloc's house in Meudon, on the outskirts of Paris.

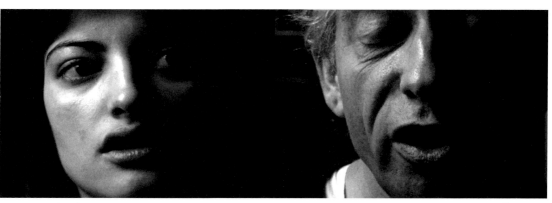

Stills from *Babel-On*, a 5 channel video-audio installation/performance by Katherine Liberovskaya (Sync-sound video) with Phill Niblock (Sound piece), 2003

Like the movements of the working hands and bodies in his films, Niblock's art is at once timeless and immediate, enduring and fleeting, concentrated and dispersed, portraying a place, a person, a movement, or a time with the same focus and attention. His genius lies in crystallizing complex thoughts. The precision of his statements define a geographical zone, an environment from which a series of films, dances, music and photographs emerges to represent it. A simple set of rules for filming the movements of people working culminates in an epic audiovisual masterpiece. A composition process lays the foundation for an entire minimalist musical oeuvre diligently carried out over 60 years.

The dance choreographies of the later *Environments* are depictions of such perpetual movements. The simple rotation, the kneeling and standing, all place the dancers as center and witness of the surrounding environment. The movements of people working, repeated from generation to generation, however rooted in traditional ways, are anchored in the time and place they are performed, whether on land, shore, or sea. For Niblock, the media chosen are but new ways to capture what was always at the core of civilizations. In situating the live performance of past recordings in a defined place, Niblock insists on several temporalities co-existing. His seminal drone music is an invitation to lose our conscious selves in the ancestral desire for continuous tones, the prehistoric nub of our psyche. His art makes us experience minute and fluid repetitions of past actions in the now of a present situation, an ethnography of sound and sight.

1. Phill Niblock was AWOL (absent without official leave but without intent to desert) for one day.
2. AHC, Phill Niblock – Matrix 4, Wadsworth Atheneum, 16–26 January 1975.
3. Unpublished note by Phill Niblock for a group exhibition with Katherine Liberovskaya and Ursula Scherrer at O'artoteca, Milan, 29 November–21 December 2007.
4. Abigail Nelson, "Who's Who in Filmmaking: Phill Niblock," *Sight Lines Magazine*, Winter 1974.
5. Unpublished and undated (after August 1975) private letter from Ralph Steiner to Phill Niblock.
6. Including "Thoughts of a Young Nun Upon Returning Home the Convent by Subway," a scenario by Itallie for Phill Niblock (film) featuring Marcia Jean Kurtz; "Baton," described as a script for a short movie to be made with Phill Niblock (some material eventually used in the short play, "Thoughts on the Instant of Meeting a Friend"); and "He said, She said," outline of scenes for a film with Phill Niblock; in Jean-Claude van Itallie Papers at Kent State University.
7. Undated program notes for the Monday Dance Series at the Village Theatre.
8. Nelson, 22.
9. Nelson, 22.
10. Nelson, 22.
11. Canada Choate, "Phill Niblock reflects on Experimental Intermedia and his loft performances," *artforum.com*, 24 December 2019.
12. Jonas Mekas, "Film Journal," *The Village Voice*, 28 May 1970, 58.
13. Gordon Mumma, quoted in Nelson, 21.
14. Nelson, 22. *Environments*, 1968, with Max Neuhaus and Ann Danoff, premiered at Judson Memorial Church, NYC. *Cross Country/Environments, II*, 1970, with Barbara Lloyd, Ann Danoff, and Vernita Nemec, premiered at Judson Dance Theater, NYC. *100 Mile Radius/Environments III*, 1971, with Barbara Lloyd and Ann Danoff, produced by the Kirkland Art Center, Clinton, NY. *Ten Hundred Inch Radii/Environments IV*, 1972, with Barbara Lloyd and Ann Danoff, premiered at the Everson Museum of Art, Syracuse, NY.
15. Phill Niblock, unpublished proposal description, 1970.

16. Phill Niblock, unpublished proposal description, 1972.
17. From a conversation with the author published in the exhibition brochure for *Phill Niblock: The Movement of People Working*, curated by Mathieu Copeland, Sketch Gallery, London, 20 January–10 March 2007.
18. Daryl Chin and Larry Qualls, ART + CINEMA, Spring 1976, published by Visual Resources, Inc.
19. With help from Adam Hogan and Laura Stayton, in 2022 Niblock edited the video transfers of all twelve Hi8 video tapes from Sumatra, 1990, and the eight hours of Hi8 tapes from Romania, 1991. Four and a half hours of Sumatra were shown at Niblock's annual Winter Solstice concert, on 21 December, at Roulette, NYC.
20. Arthur Stidfole, "Some Reflections on Phill Niblock and EIF," in *Phill Niblock, Working Title*, Les Presses du Réel, 2013.
21. Tom Johnson, private correspondence with the author, 12 January 2023.
22. Notes by Phill Niblock in undated (ca. mid-1980s) self-published artist statement.
23. Phill Niblock, "Notes for Niblock for Celli/Celli plays Niblock," produced by EIF and India Navigation, 1984.
24. John Cage, "The Future of Music," originally appeared in 1974 in *Numus West*; revised in 1979 for *Empty Words : Writings '73-'78 by John Cage.*
25. Notes by Phill Niblock in undated (ca. mid-1980s) self-published artist statement.
26. Ibid.
27. Phill Niblock, "Niblock for Celli/Celli plays Niblock."
28. Bernard Gendron, "Experimental Intermedia Foundation and the Downtown Music Scene," in *Phill Niblock, Working Title*, Les Presses du Réel, 2013.
29. Guy De Bièvre, *Life All Over*, catalog essay for *Phill Niblock*, Gahlberg Gallery, College of DuPage, Glen Ellyn, IL, 16 April–26 May 2007.

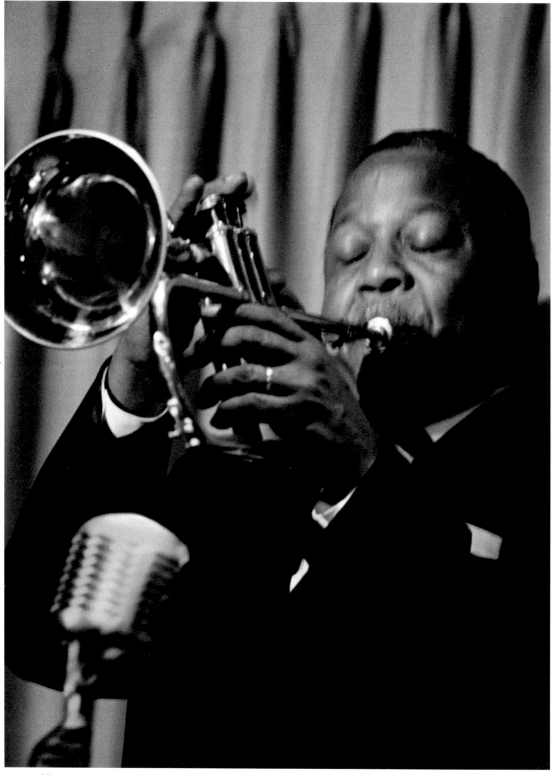

Roy Eldridge, flugelhorn, at the Metropol Bar on Broadway

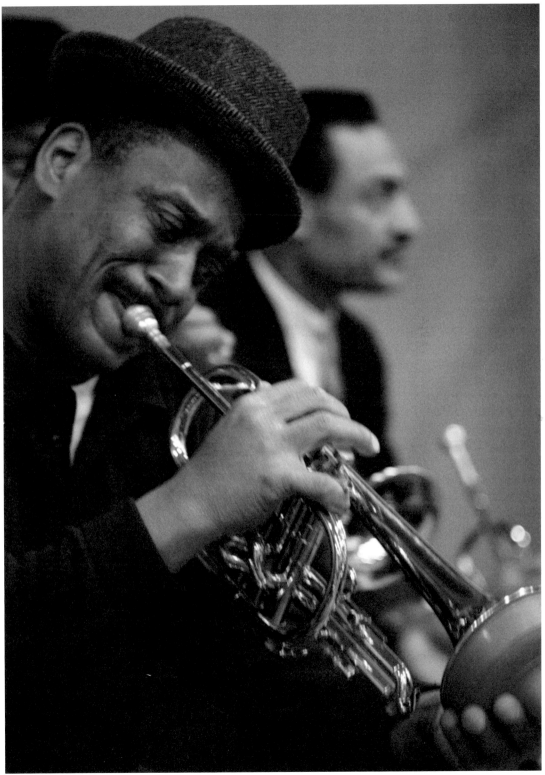

Ray Nance, cornet, with Roy Burroughs in background

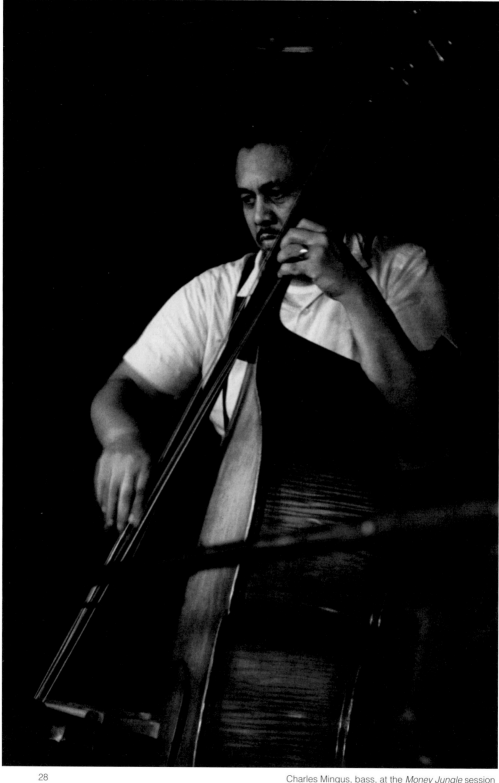

Charles Mingus, bass, at the *Money Jungle* session

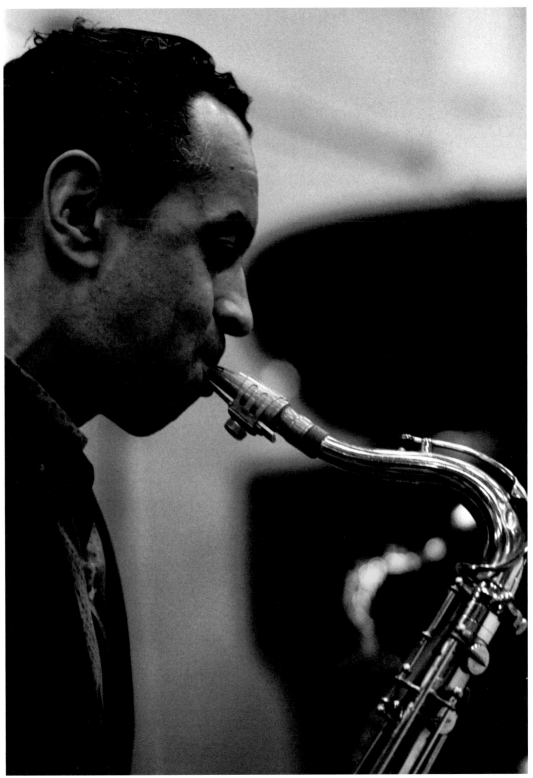

Paul Gonsalves, tenor saxophone

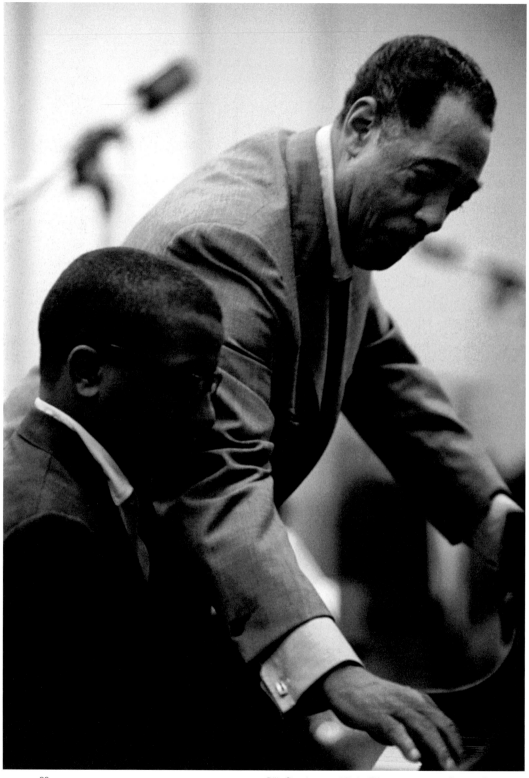

Billy Strayhorn and Duke Ellington at a recording session

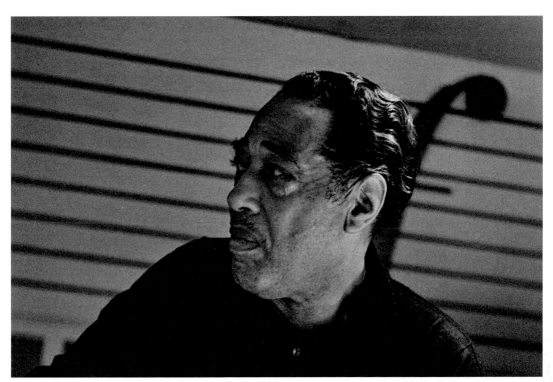

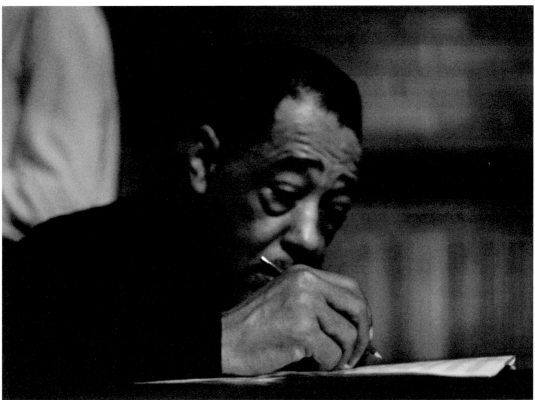

top: Duke Ellington in a recording booth. bottom: Duke Ellington between sets, backstage at a concert in a theater in Plainview, Long Island. Niblock's first portrait of Ellington

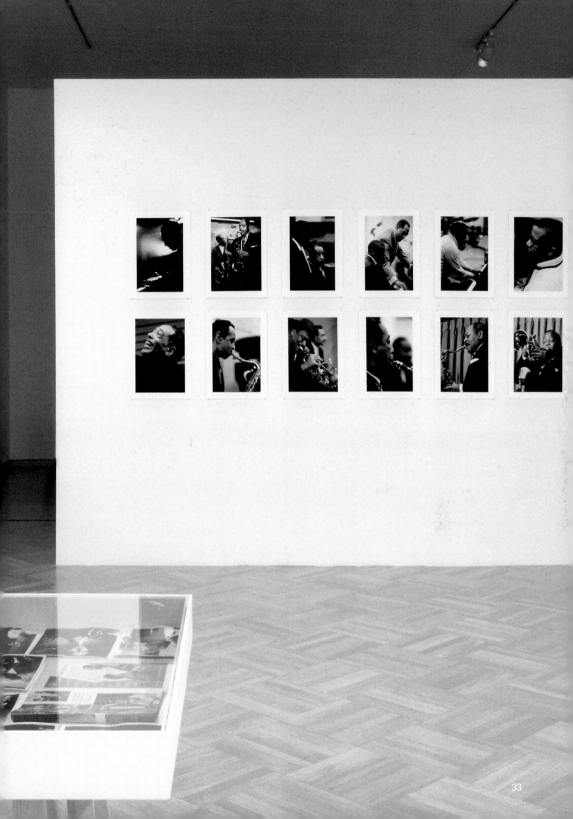

The Jazz Photographs, 1960–64

Underground Gallery

51 East 10th Street New York, New York 10003

Opening: February 4, 7 p.m. to 10 p.m.

Gallery Hours:

Tuesday–Friday, 7 p.m. to 10 p.m.

Saturday–Sunday, 2 p.m. to 5 p.m.

Closed Monday

Telephone SP 7-3561

Phill Niblock

February 4–27, 1966

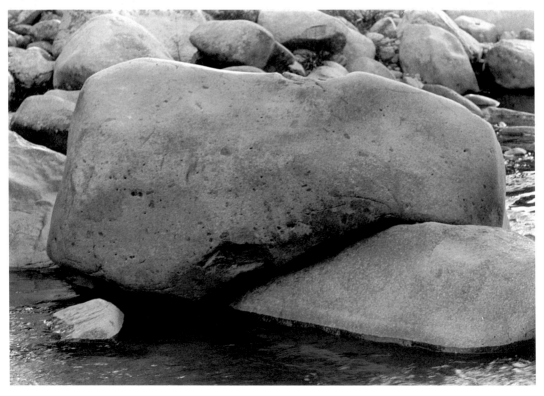

Invitation card for *Phill Niblock*, Underground Gallery, 1966

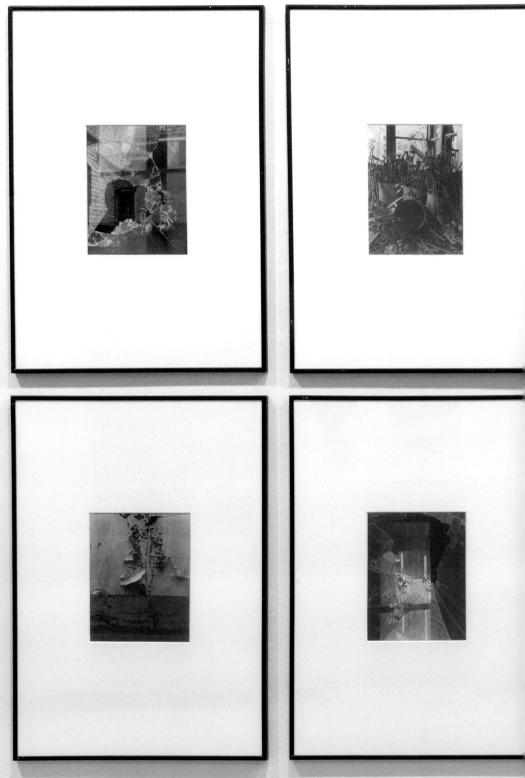

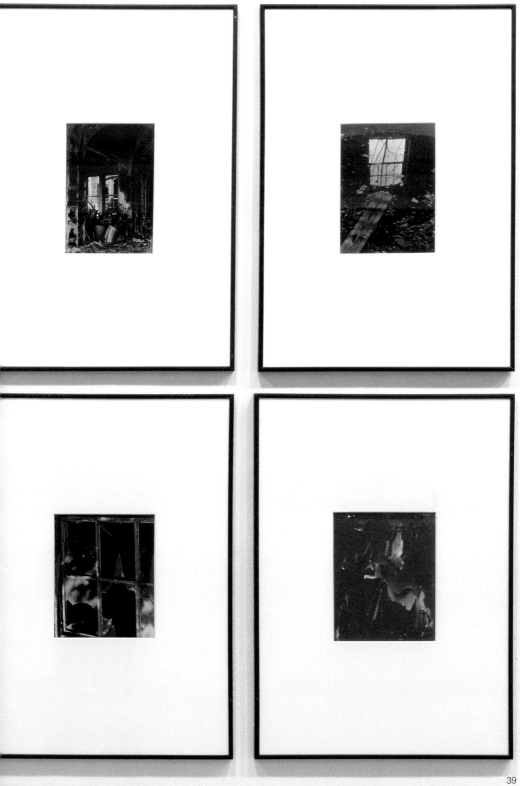

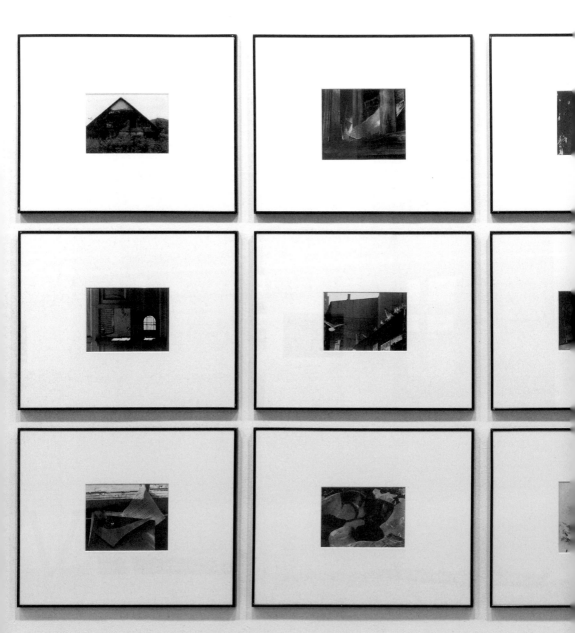

Phill Niblock, Underground Gallery, 1966

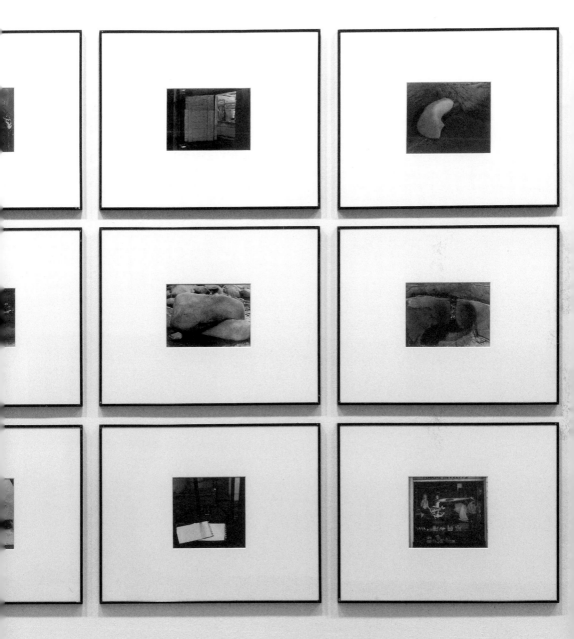

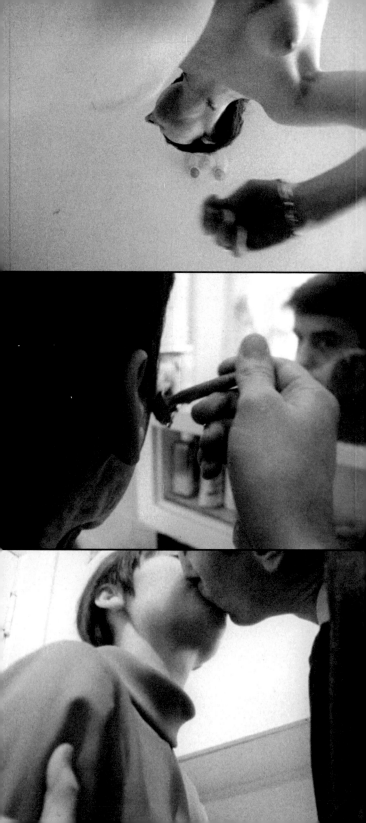

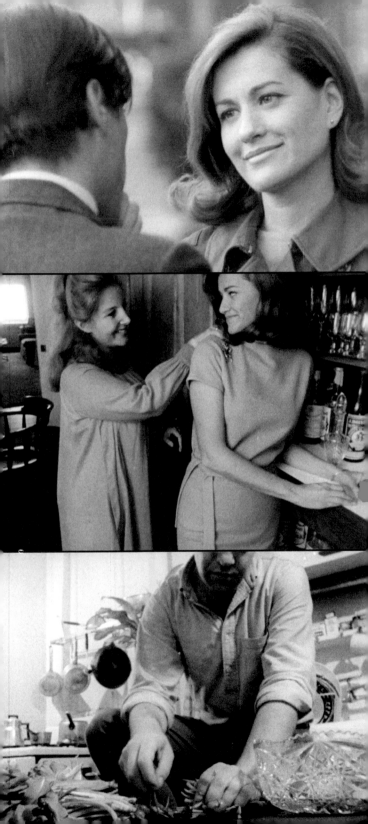

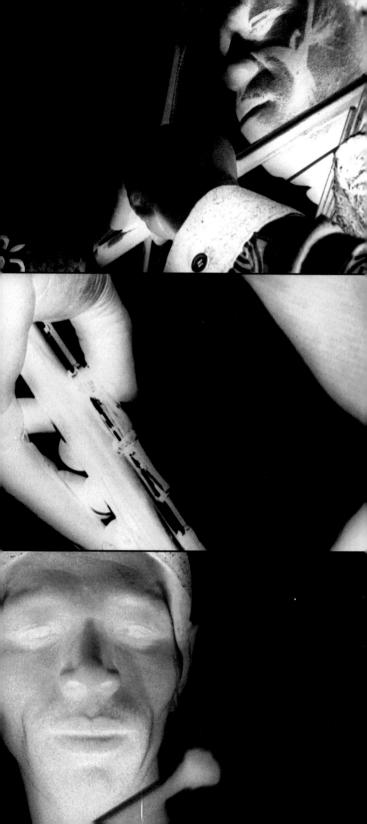

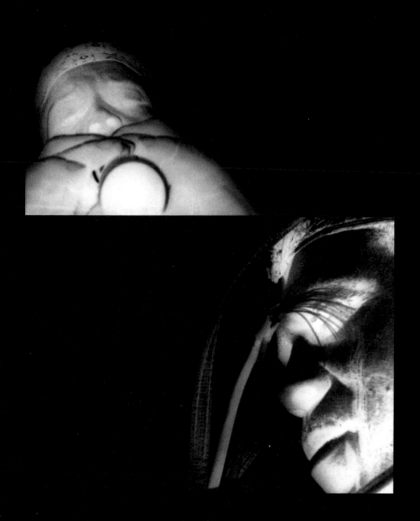

THE
MAGIC
SUN

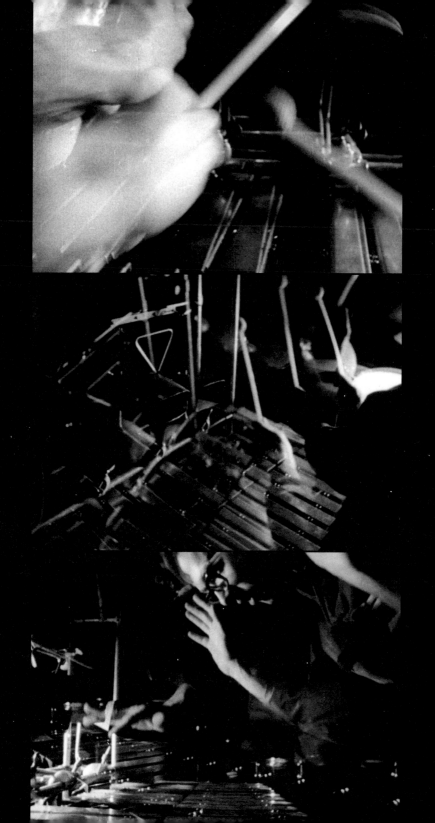

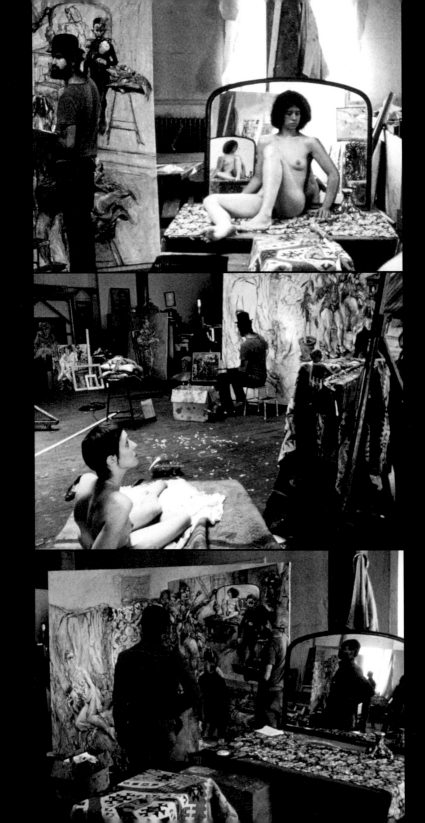

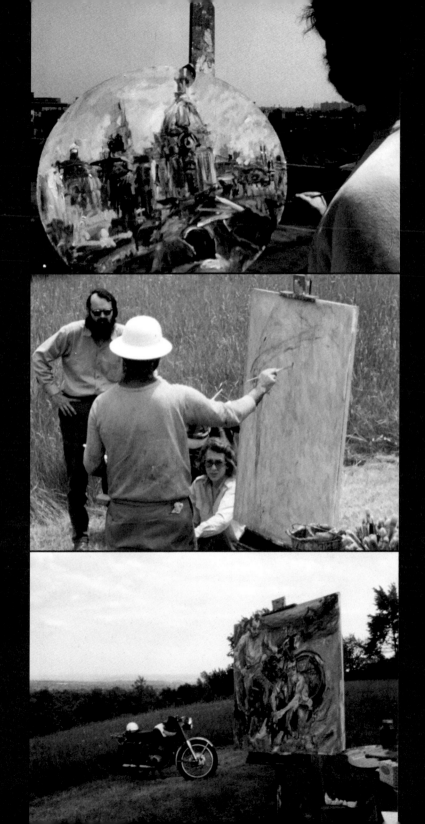

49

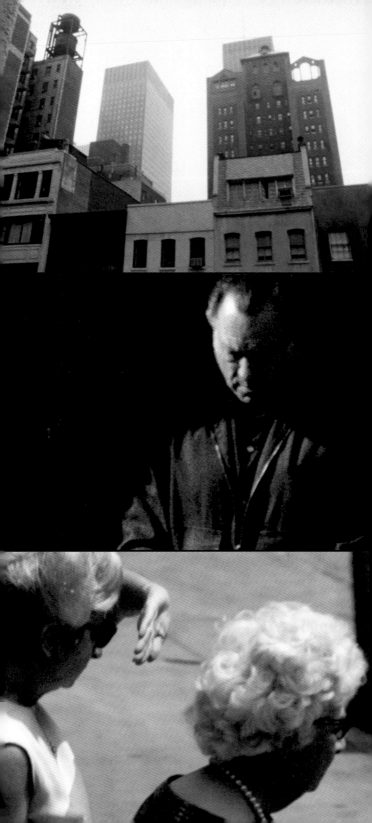

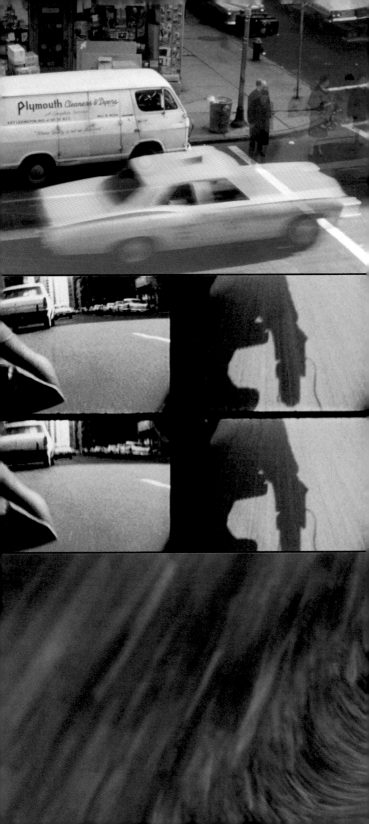

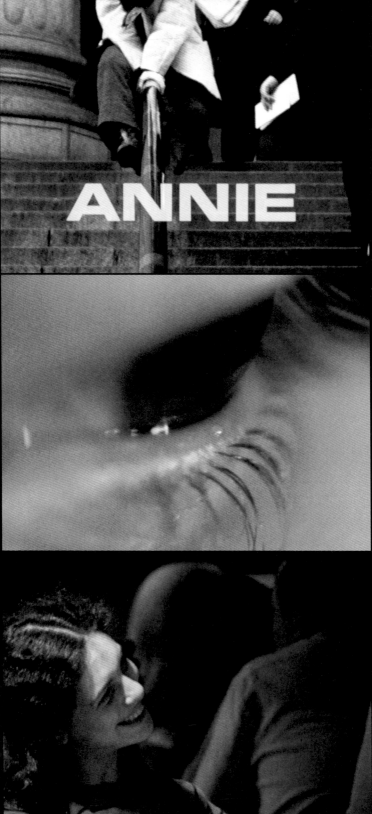

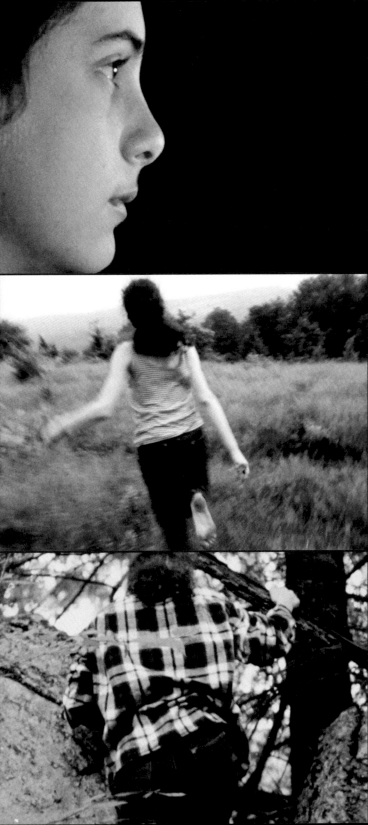

Six Films, 1966–69

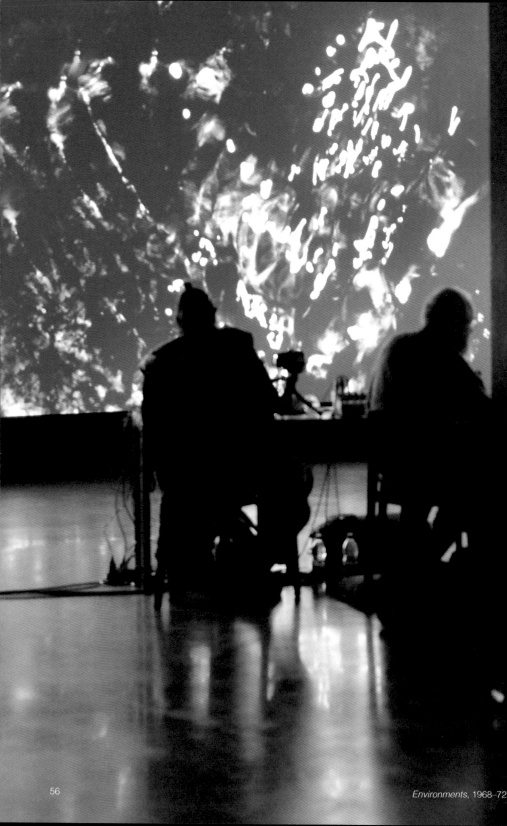

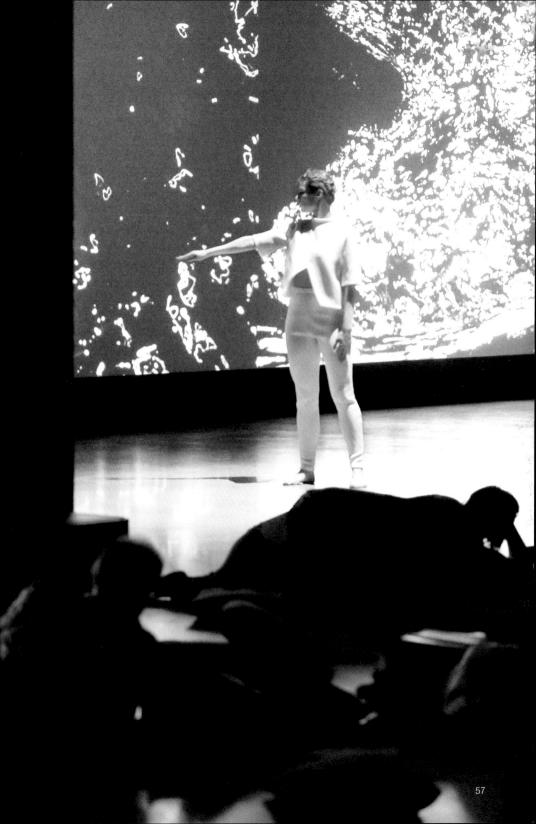

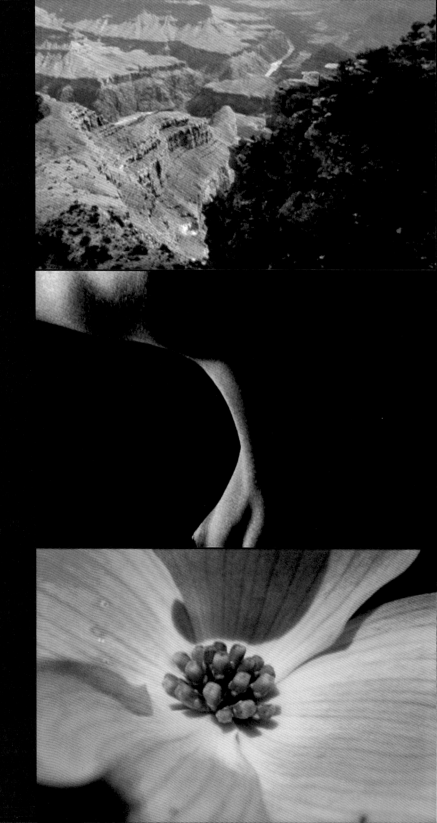

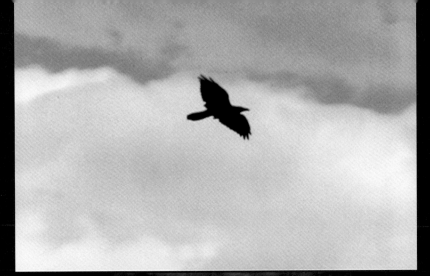

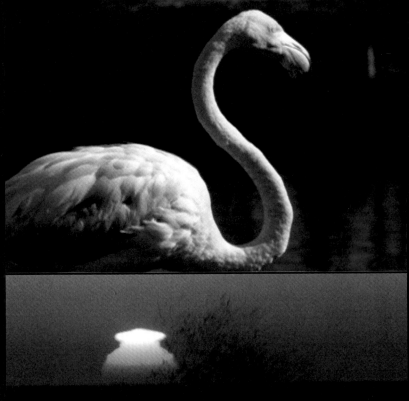

100 Mile Radius, Environments III, 1971

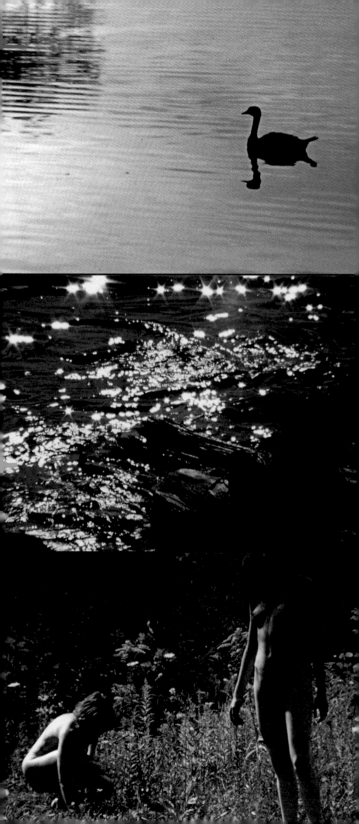

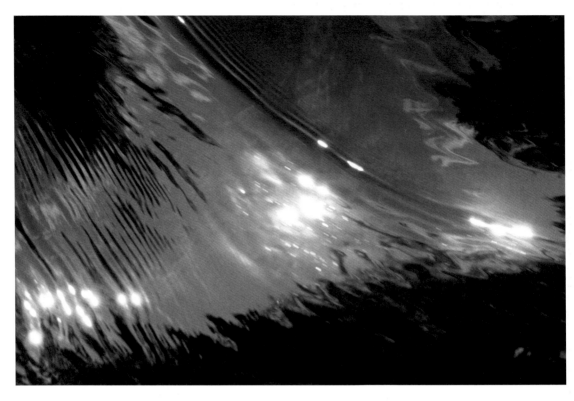

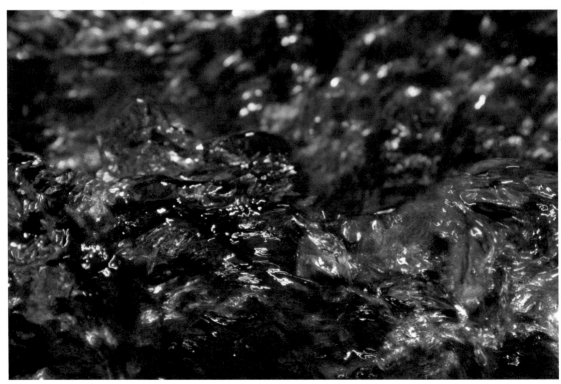

Ten Hundred Inch Radii, Environments IV, 1972

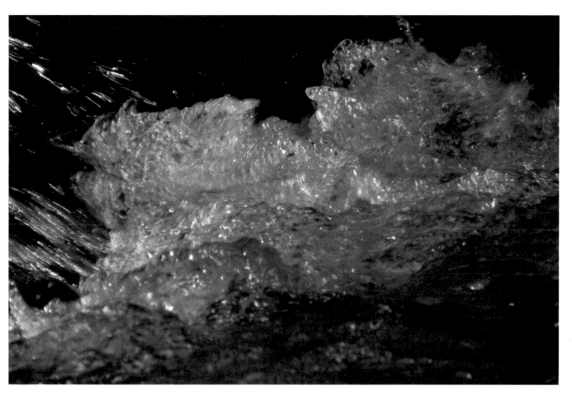

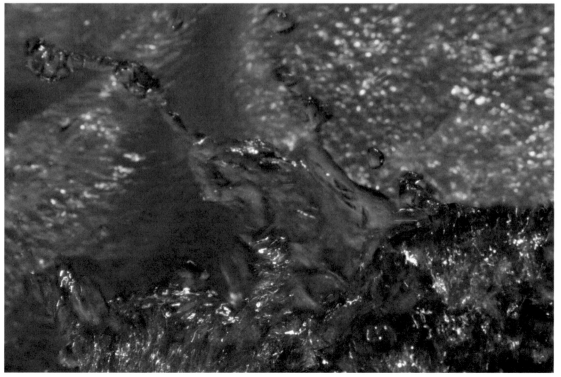

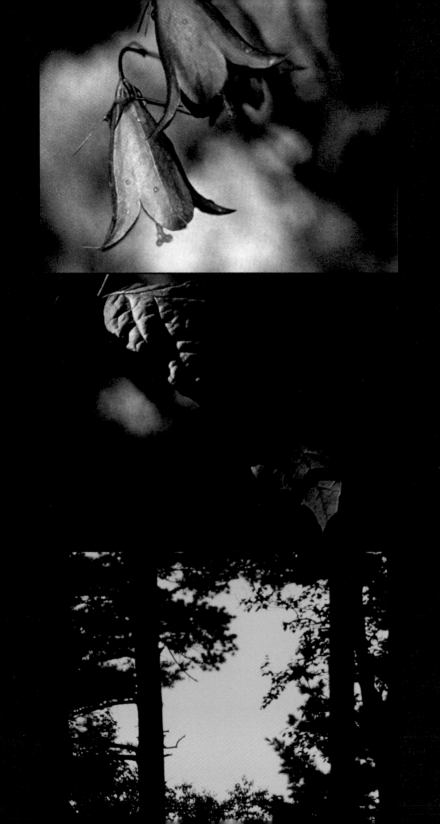

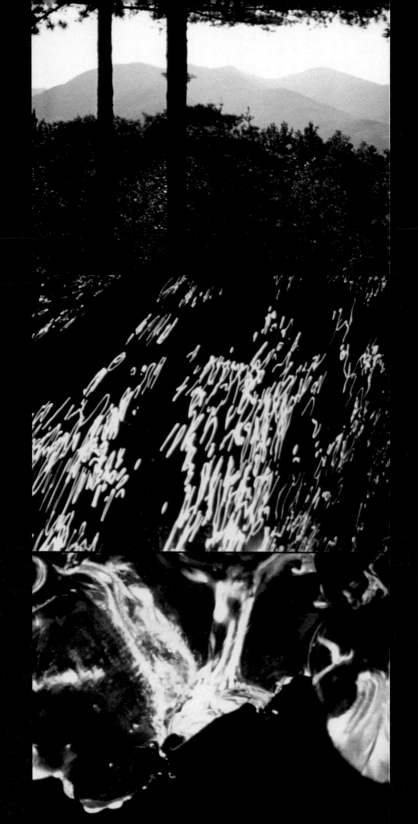

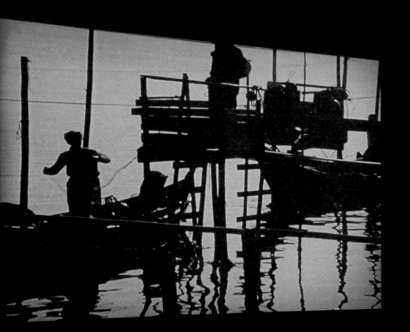
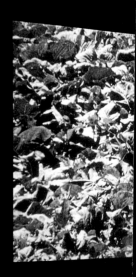

The Movement of People Working, 1973–91

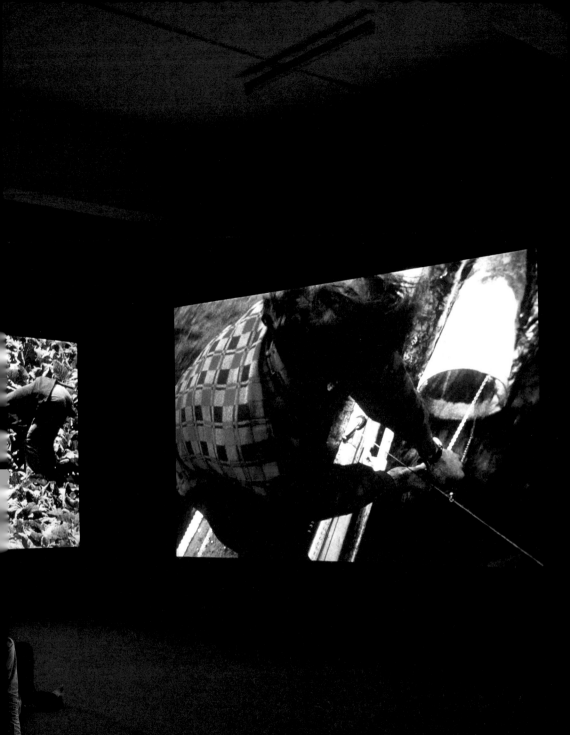

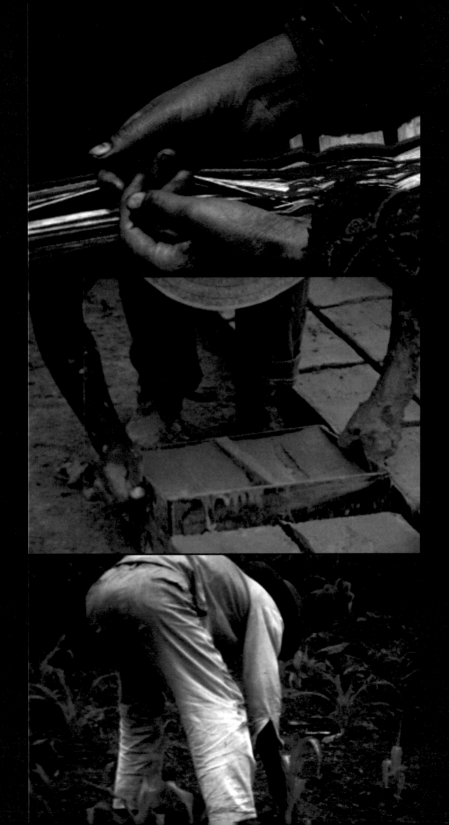

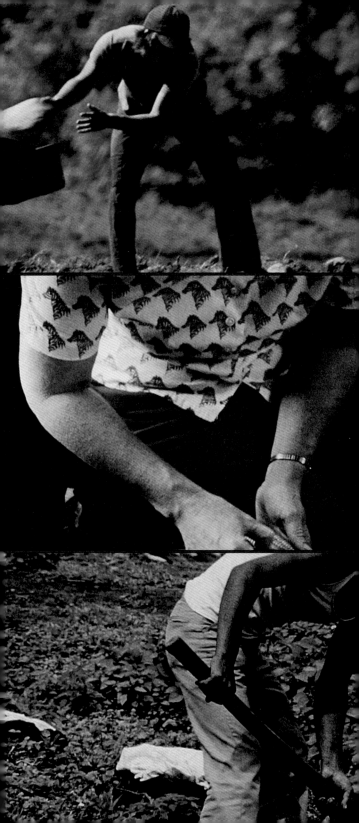

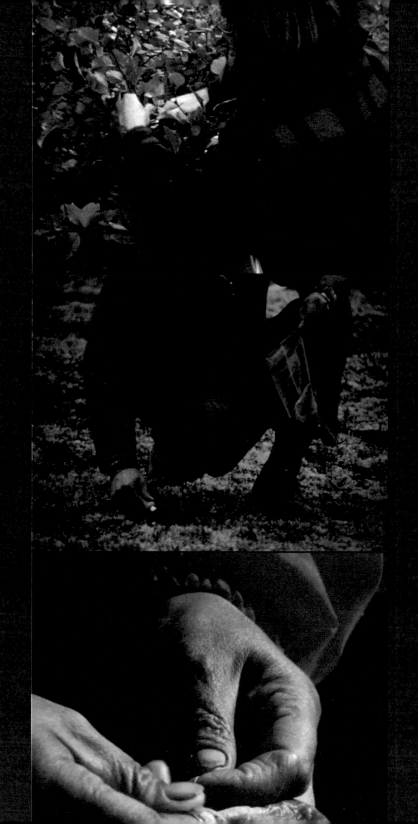

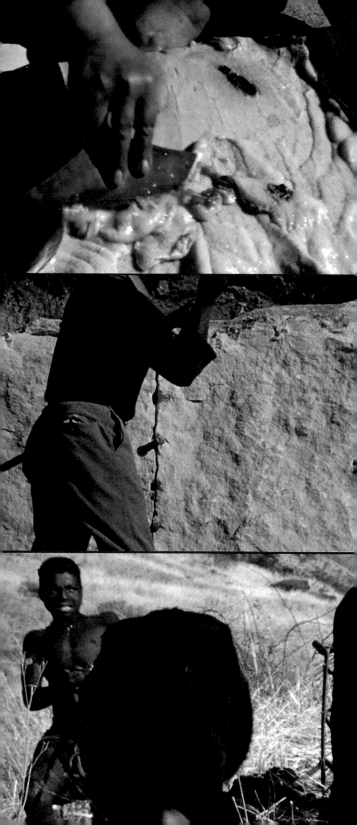

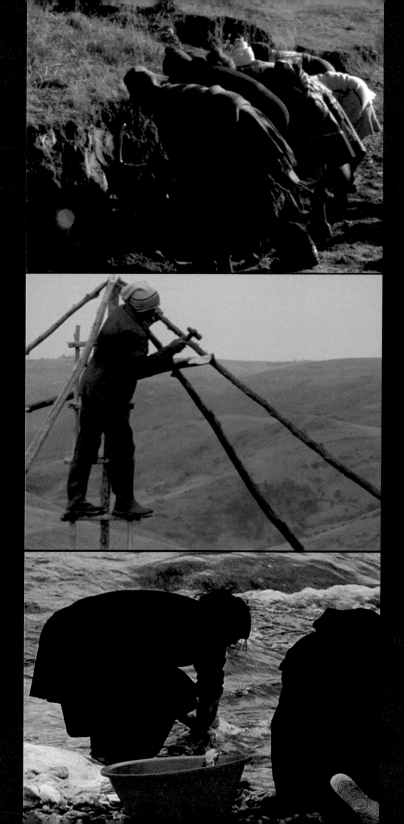

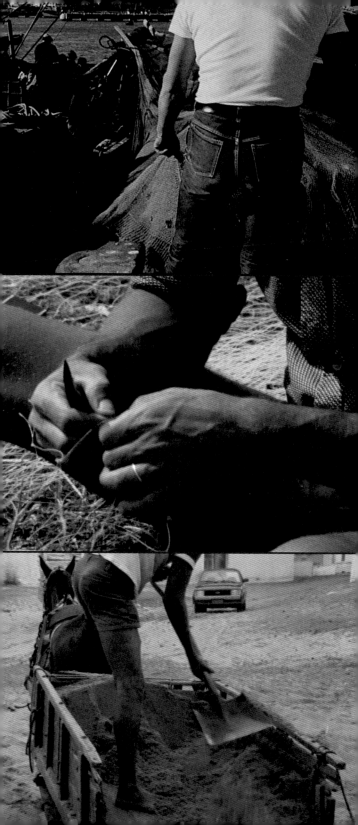

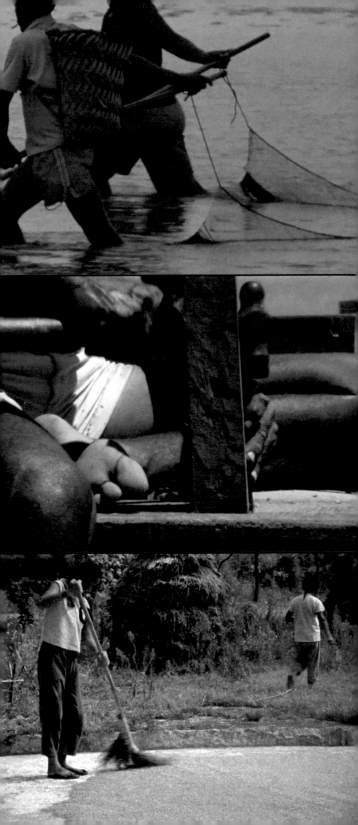

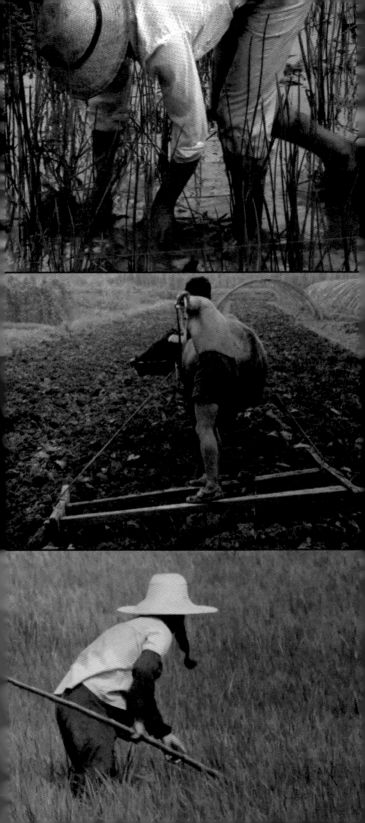

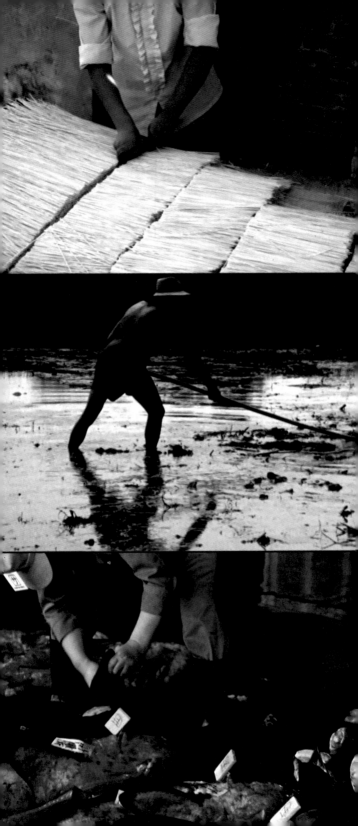

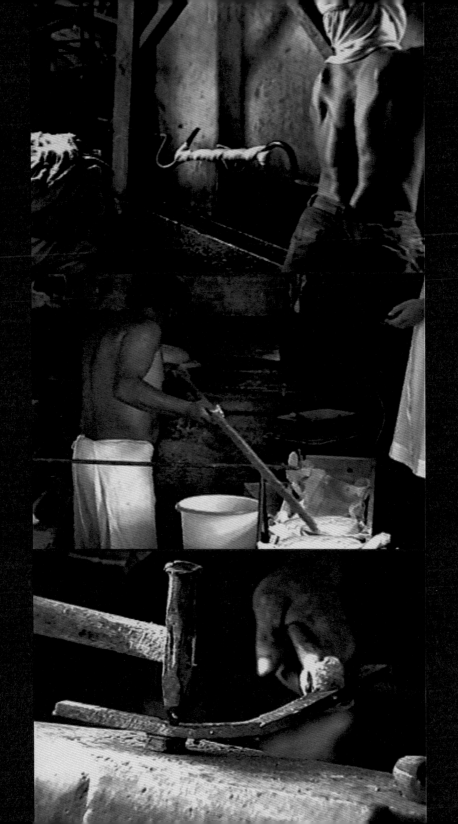

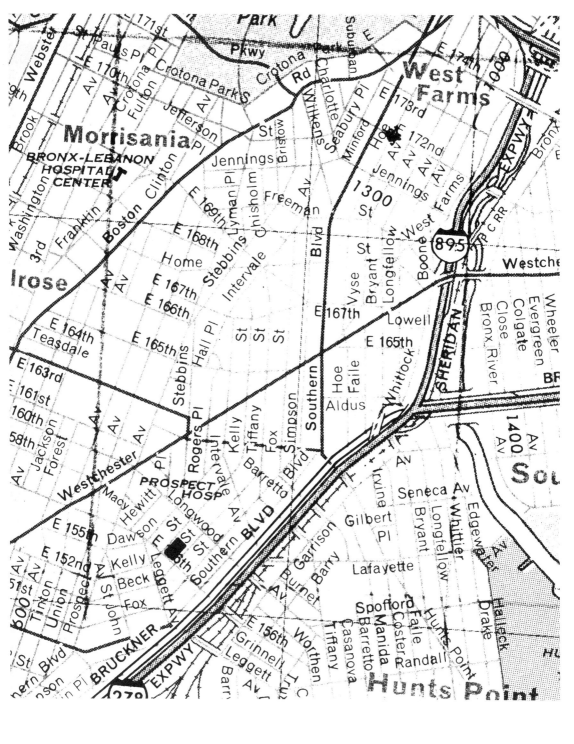

Map, *Streetcorners in the South Bronx*, 1979

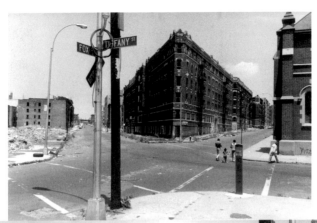

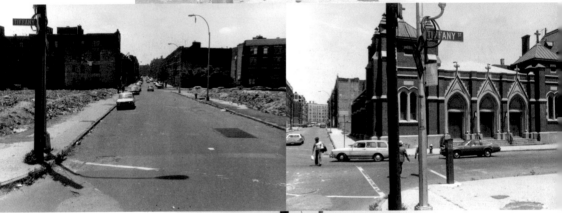

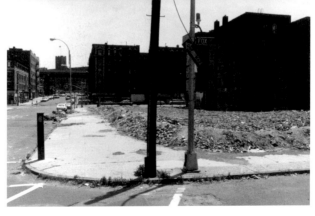

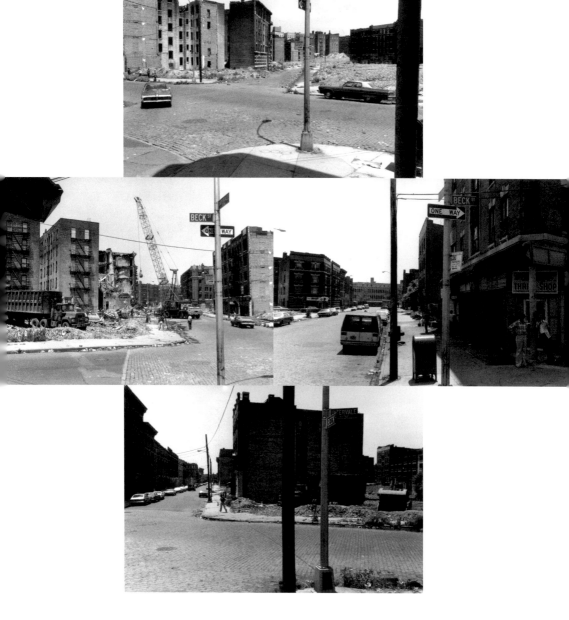

Streetcorners in the South Bronx, 1979

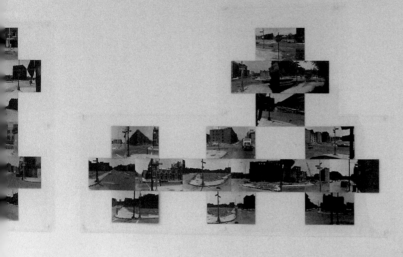

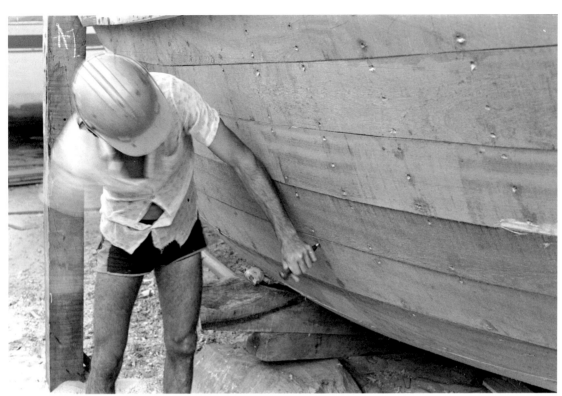

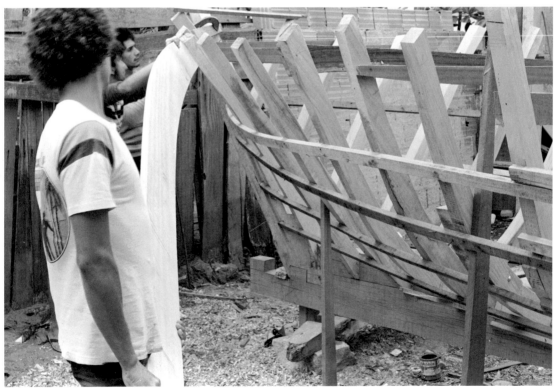

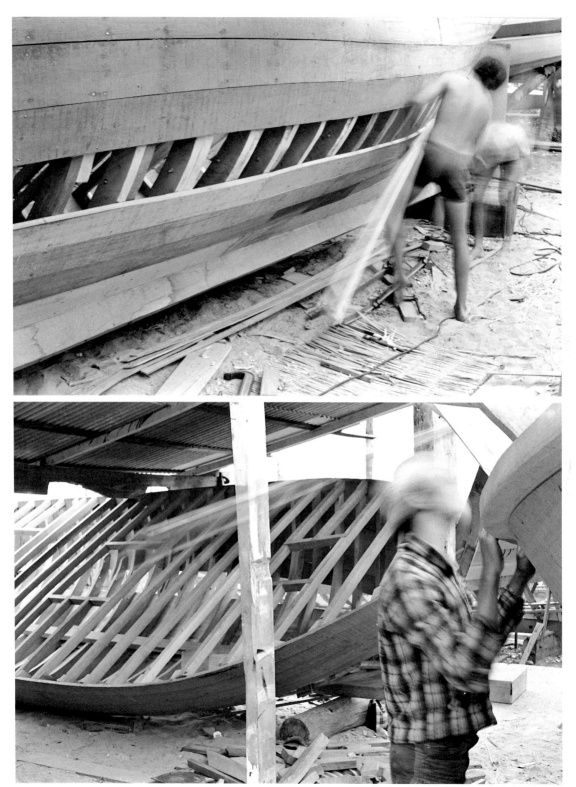

Brazil Boatyard, 1984

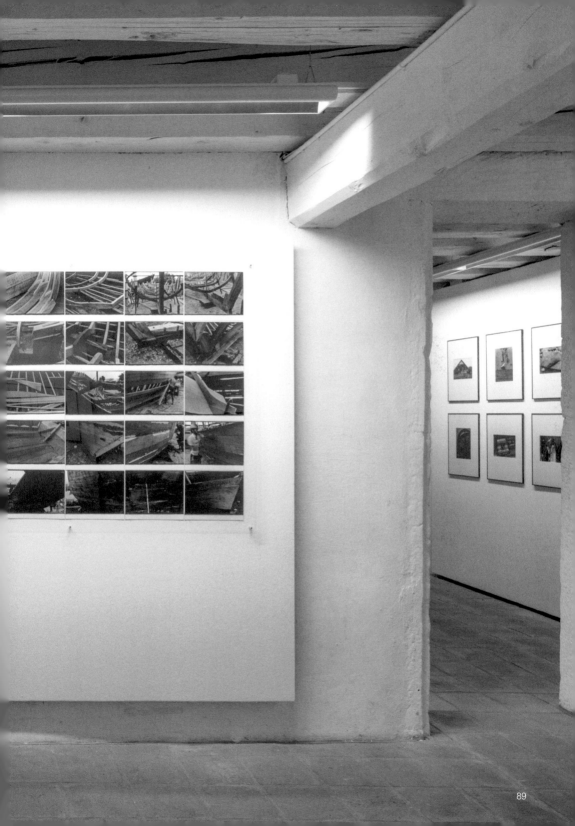

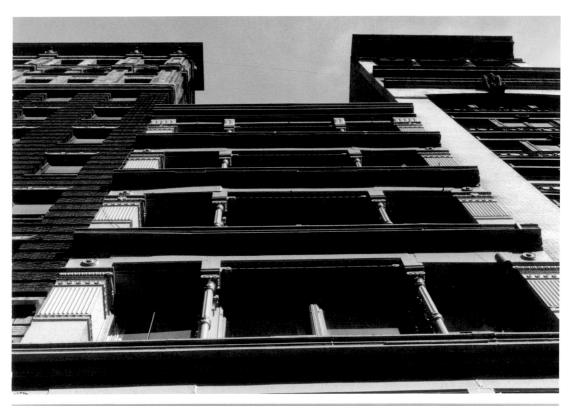

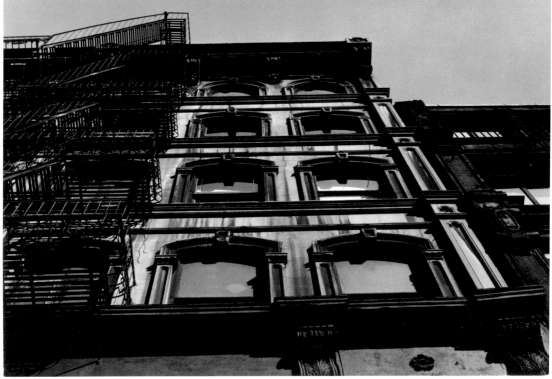

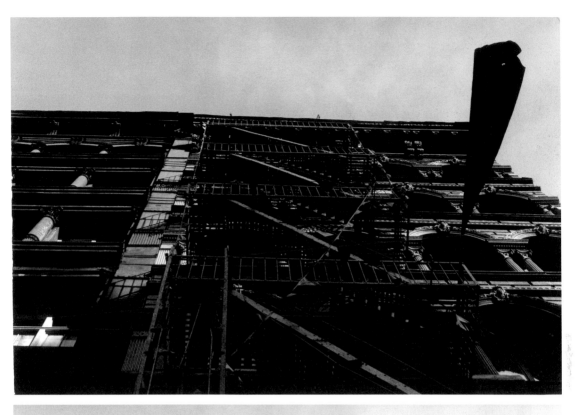

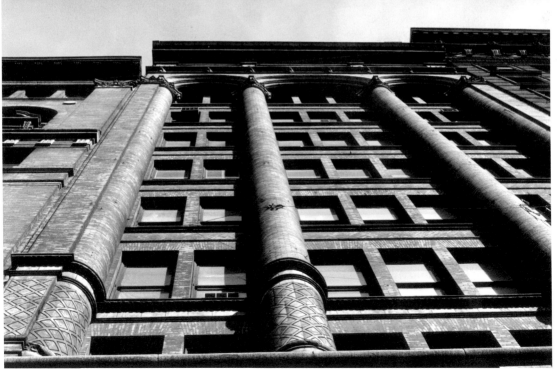

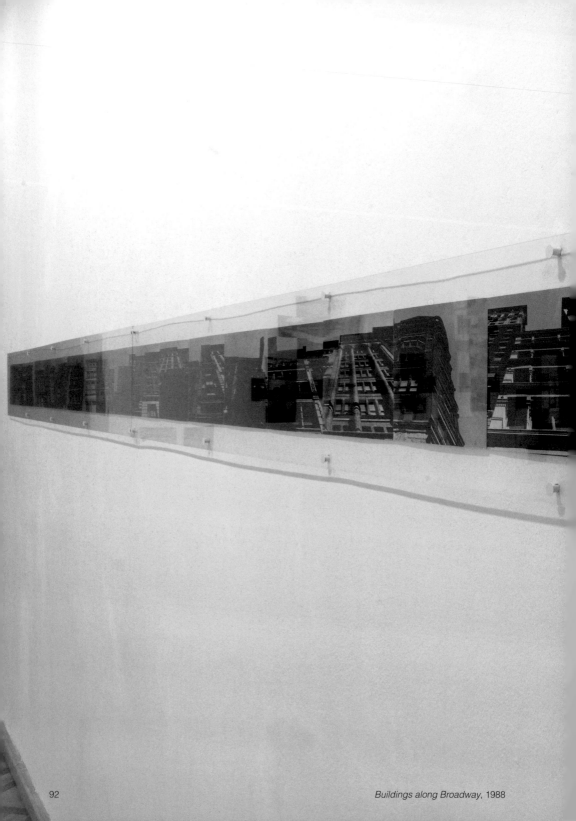

Buildings along Broadway, 1988

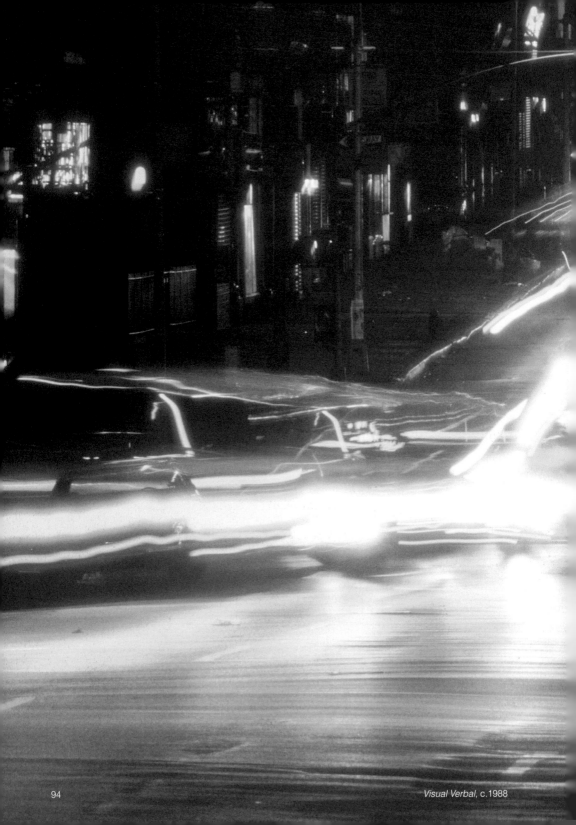

Visual Verbal, c.1988

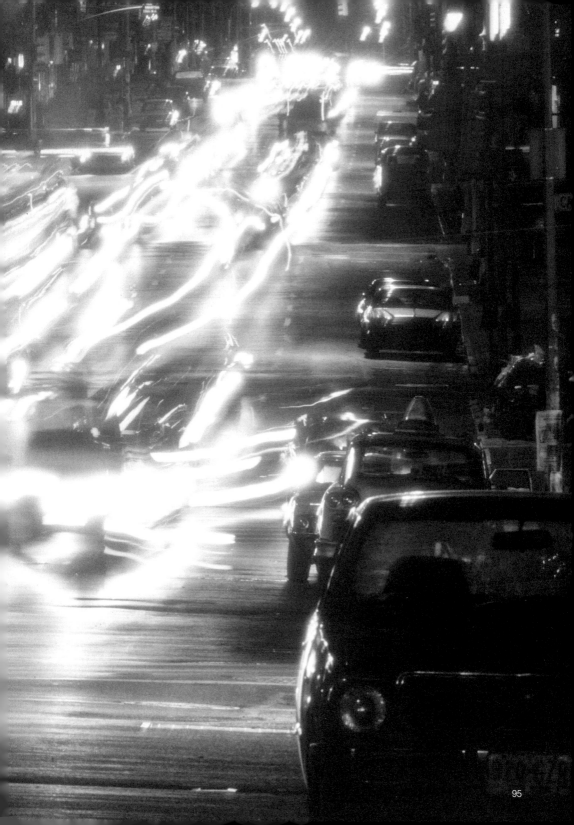

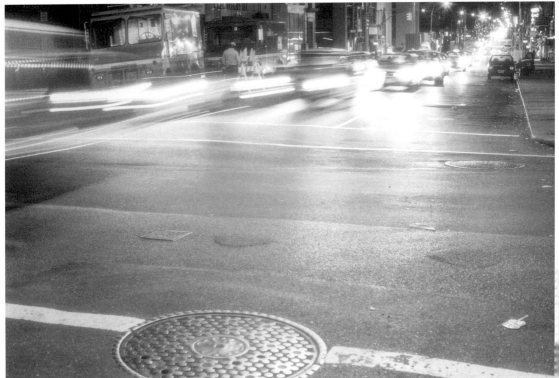

97

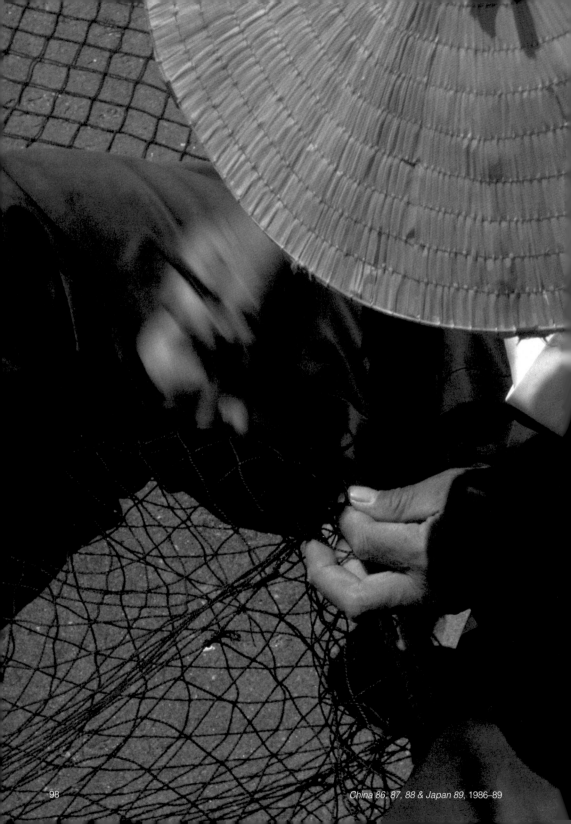

China 86, 87, 88 & Japan 89, 1986–89

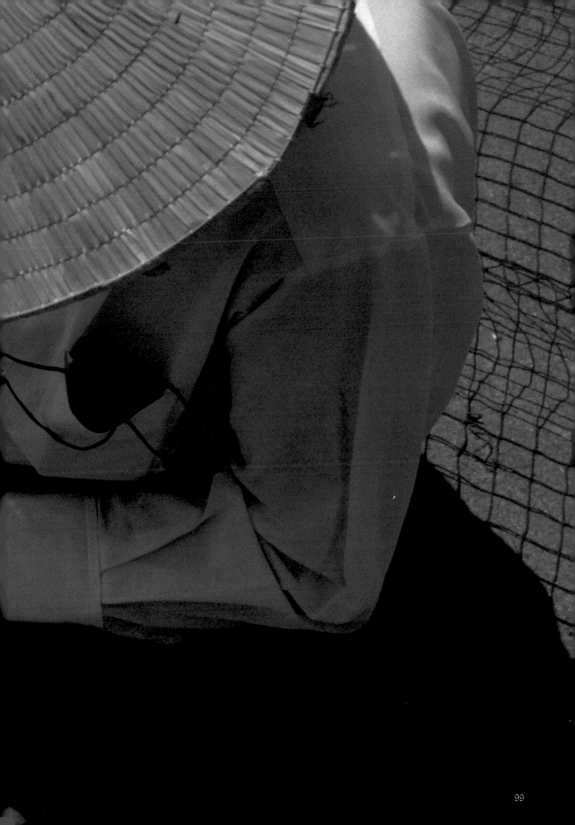

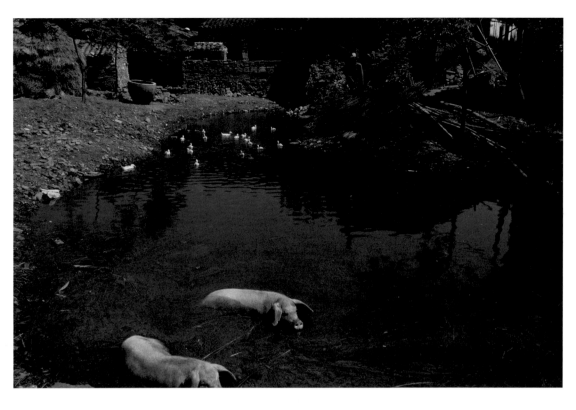

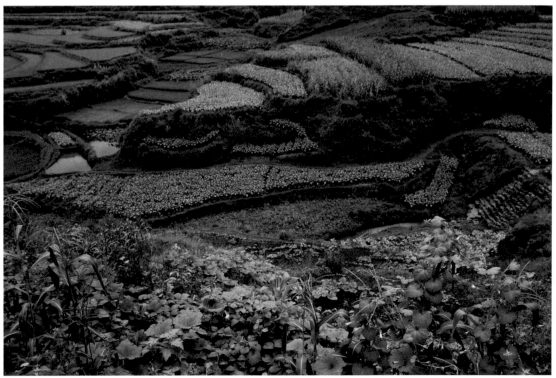

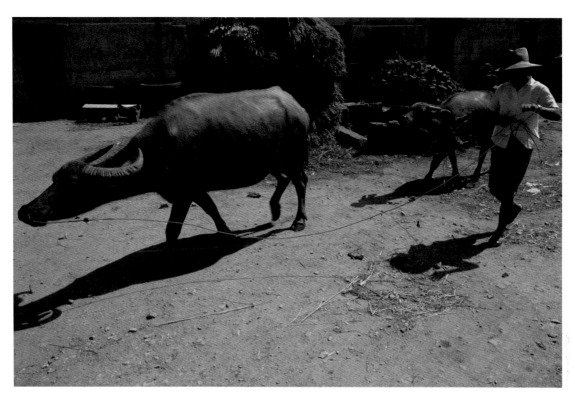

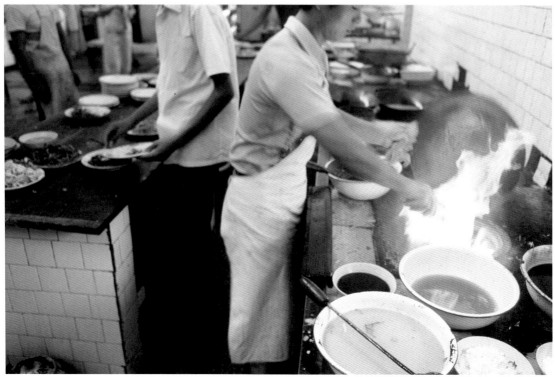

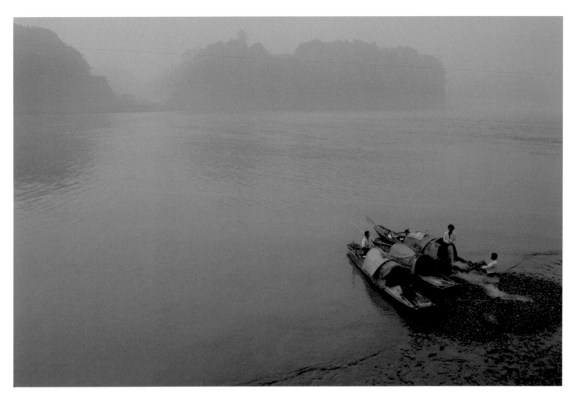

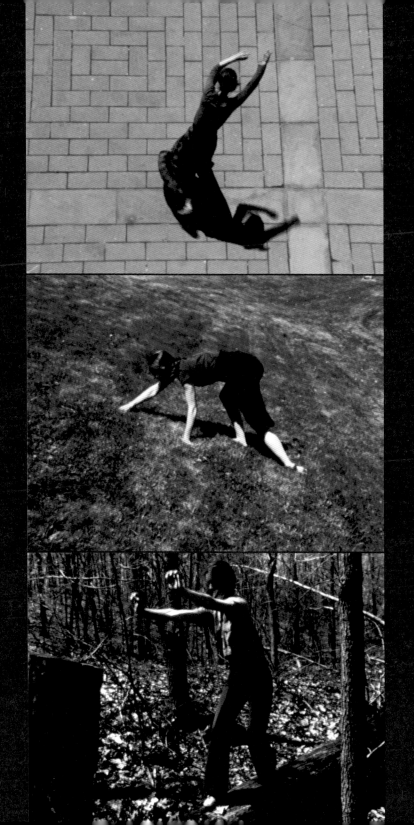

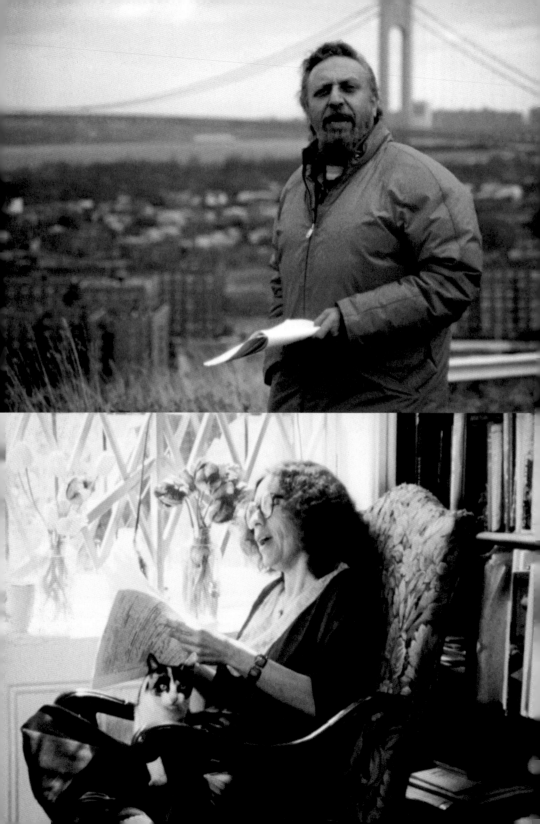

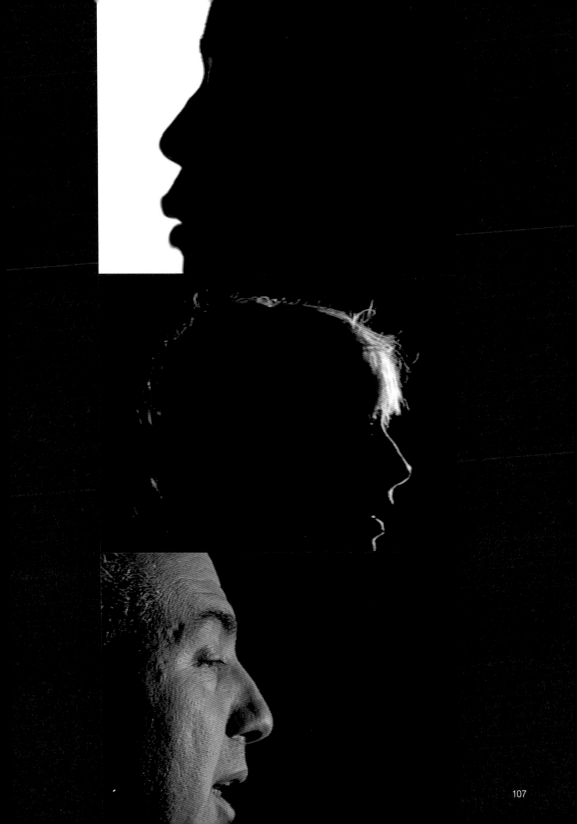

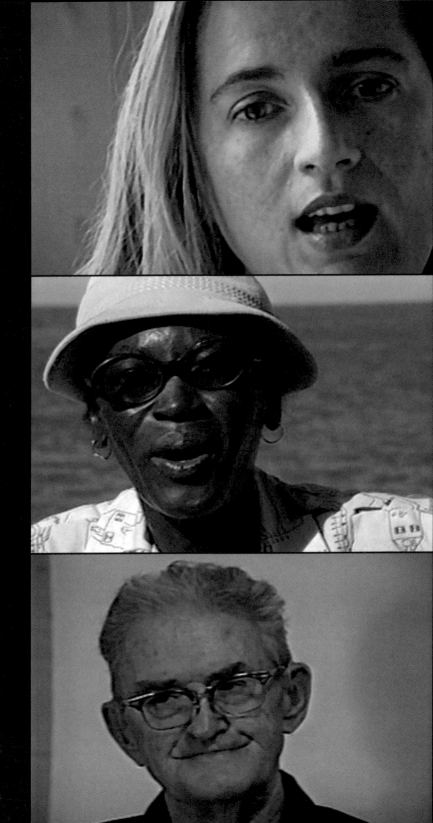

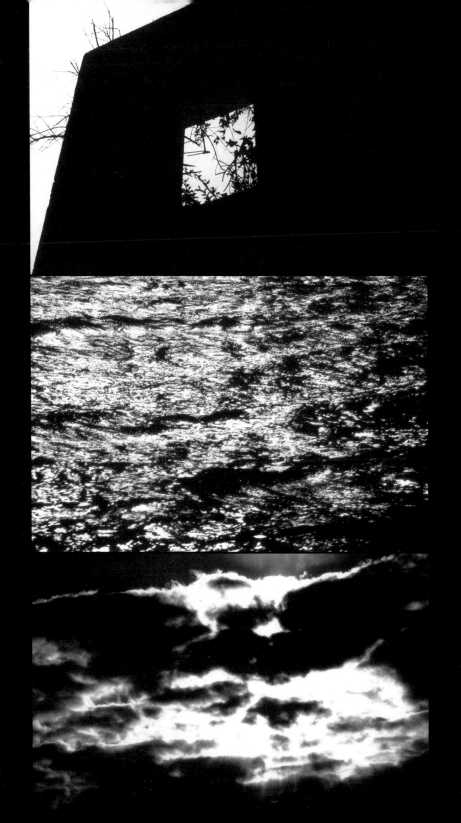

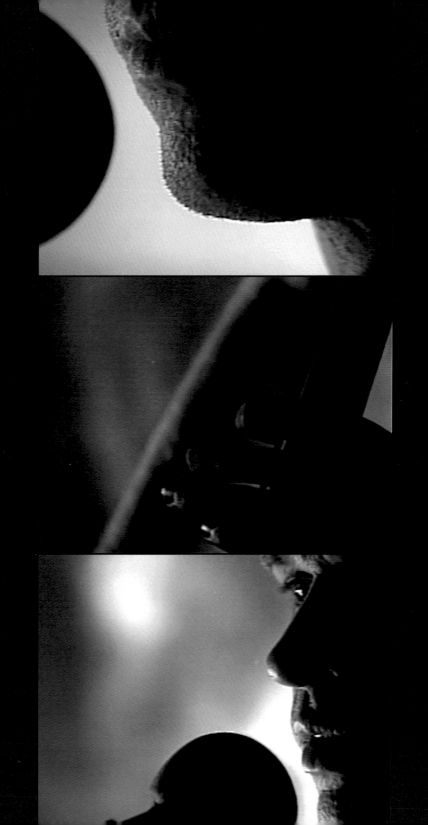

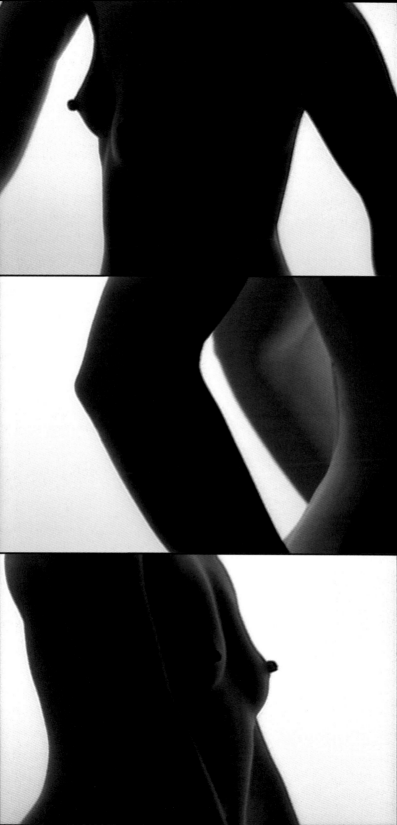

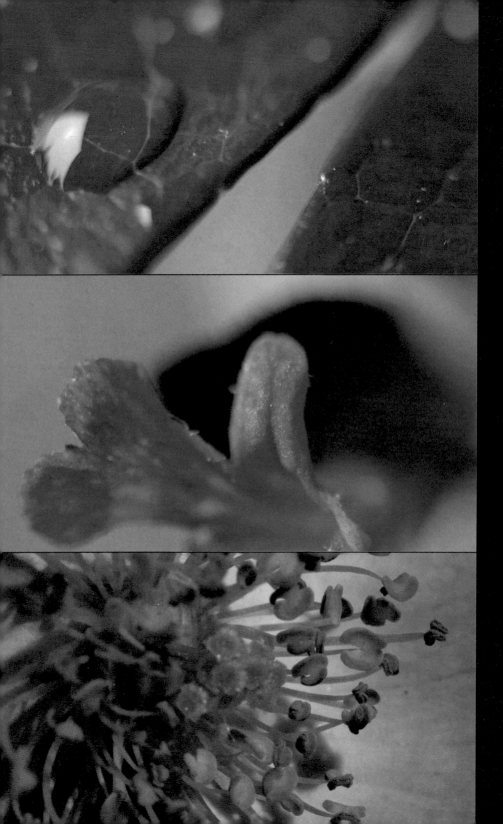